DRAWING BY ALDREN A. WATSON FOR GULLIVER'S TRAVELS
Illustrated Junior Library
Grosset & Dunlap, Publishers

HOW TO USE

CREATIVE

PERSPECTIVE

Ernest W. Watson

REINHOLD PUBLISHING CORPORATION
New York

This book is gratefully
dedicated to my wife Eve,
partner in its preparation

contents

Ernest W Watson

WHAT IS CREATIVE PERSPECTIVE?

The answer will be found in the work of top contemporary illustrators whose work is reproduced and analyzed in this book. As their pictures are studied, it will be seen that they are more dramatic and more convincing because the artists took broad liberties with textbook rules, often *violating* the academic methods of scientific perspective.

How to violate perspective (profitably) is fully as important for a practicing artist as are the rules of perspective, which are quite simple. When rules are violated and perspective effects are achieved through the artist's own devices, his methods can be called "creative."

This book has been written for the student who, while in no less need for thorough knowledge of academic method, ought also to learn that by using perspective creatively he can bend it to his uses rather than be limited always to strict conformity.

Another factor which makes this book timely is the very great influence upon picturemaking—hence on perspective—of the airplane, the cinema, and modern photographic concepts. They have introduced new ways of looking at our familiar world, ways that have made us radically revise some concepts of perspective appearance.

Then there is "modern art" which defies tradition and projects revolutionary viewpoints into the art of picturemaking, freeing the artist from slavery to conventions that formerly were considered inviolate. All of these influences have made the older texts obsolete in part.

Although the creative aspects of perspective are emphasized in this book, the academic precepts are demonstrated sufficiently to give the student of freehand perspective what theoretical knowledge he needs to have of conventional practice—having in mind the beginner who first needs step-by-step introduction to this subject.

1
*Drawing by the author
as an advertisement
for Eldorado Pencils.*

2

Fifteenth century woodcut by an artist who had no knowledge of scientific perspective.

The facts of perspective, to repeat, are quite simple. They can be learned readily by anyone of ordinary intelligence. The only difficulty lies in their effective use by the artist. By *effective* use I mean something other than their correct application to picturemaking in a photographic sense. Such use may not be effective at all. Effective perspective more often than not is to be had in *violation* of photographic reality and the so-called "rules" of mechanical procedure. (Throughout the book the term *photographic reality* or *photographic appearance* is used to refer to such a transcript of nature and objects as is recorded by the camera.) Photography comes nearest to being what we see, or *think we see,* with the physical eye. In reality, no picture—photographic or otherwise—can duplicate what our eyes see. For one thing, the camera picture is recorded on a flat plate or film; the retina of the human eye is concave.

All pictures, we must recognize, are a compromise with what the eye actually sees. The assumption in perspective theory is that the artist's direction of sight does not change in the making of his picture. As a matter of fact, it is never static; his eye restlessly darts here and there over the entire area of the scene without being conscious of doing so. It has to, because the eye can focus only upon a single point—and a very limited one—at one time.

In spite of this inconsistency, we have been taught to predicate our method upon the erroneous assumption that every picture is in reality the record of what can be seen without shifting the gaze from point to point. We establish what is known as the *center of vision,* and give the picture plane a fixed relation to it. There are exceptions to this procedure, as we shall see.

Some of the greatest art of past centuries—yes, most of it—has been produced by artists who have been either ignorant of or indifferent to scientific methods of representation. Long before the early Renaissance when modern perspective procedure was first used, painters were employing a sort of perspective that suited their purposes very well indeed. Some moderns might even maintain that truly creative painters were better off without the "tyranny of rules" which, admittedly, has weakened the work of many painters in periods when slavish adherence to scientific perspective has been regarded as essential to good picturemaking. Although unaware of the rules of perspective as taught today, the old fellows knew enough about appearance to make their pictures sufficiently realistic. The Chinese, the Japanese and all oriental artists throughout the centuries got along very well without perspective rules and gave the world much of its greatest art. But, in recognizing this, we must at the same time remember that before the

3

"Abandoned Powerhouse," an oil painting by Julian Levy,
collection of A. L. Simmons.
In this picture the artist, being familiar with scientific
perspective, violated it for the sake of design.

invention of perspective the painter's public was used to these strange
—to the modern eye—methods of representation. The entire concept
of picturemaking was quite unlike that of our present era, which
demands the appearance of *reality* in illustration as people have come
to conceive it in terms of photographic appearance. But even the
concept of photographic reality has recently changed. Modern photo-
graphic practice has accustomed us to the camera distortion of close-
ups and odd angle exposures which not so long ago would have violated
our sense of reality.

And modern art—I am speaking of painting now—frowns upon nat-
uralism. The modernist actually flouts scientific perspective, goes out
of his way to avoid it. In this philosophy, nature painting is not art
at all and the further the artist gets away from it the better. At any
rate, perspective as used by the modernist is quite different from that
employed by the naturalistic or illustrative painter. The latter uses
perspective to give a realistic appearance of distance—of *going back
into the picture.* The modernist distorts scientific perspective in order
to *flatten out the depth effect* into two-dimensional pattern. He tries to
keep his painting "on the picture plane"; that is, on the surface of the
canvas.

Conservative painters continue to employ perspective devices that
give emphasis to photographic appearance. But the best of these con-
servatives are by no means slaves to mechanical rules. They take many
liberties with perspective that to the layman's eye may not be obvious.

What I have just been saying applies particularly to the painter.
The illustrator's problem is entirely different; his function, usually,
is to depict the facts and events of the familiar world with as much
realism as possible. He must make his pictures look *natural.* Photo-
graphic perspective—that is, scientific perspective—is indispensable to
his purpose. Yet even the *creative* illustrator is not a slave to his per-
spective. Although he has to be thoroughly conversant with theory,
in practice he favors design when design is in serious conflict with
perspective. And he has adopted, to a considerable extent, the mod-
ernist's intentional distortion. Such distortions have indeed become
a vogue in contemporary drawing. A large body of present-day illus-
tration, which might be typified by Richard Erdoes' drawing, achieves
a liveliness and design distinction while it ignores perspective rules.
But Erdoes is as thoroughly versed in perspective as anyone could
be; what is more, he could not have achieved the beauty of this "art-
less" drawing were he not a master of perspective.

The existing conflict between design and perspective in picture-
making may be a new thought to beginners, but the serious art student

4

"Street Scene in Morocco"
from Column *Magazine, by Richard Erdoes.*
An exciting drawing by a top
illustrator, in which scientific
perspective has been flouted for the
sake of an amusing design.

soon becomes aware of it. More and more he discovers that the demands of design—that is, the arrangement of lines and tones needed for effective composition and for the clear expression of his idea—*force* him to violate perspective rules; and his picture actually may be more convincing when his lines do not conform to photographic reality.

Every one who draws or paints, in whatever manner, ought to be completely conversant with the laws of scientific perspective. Unless fortified with this knowledge the artist is ill-equipped either to draw accurately or to take liberties with the facts of appearance. The great majority of artists, and all illustrators—even those who most often *seem* to do without it—frequently are called upon to put the facts of scientific perspective to meticulous use in their work. Without intimate knowledge of it and great skill in its practice, no one can pose as a professional illustrator.

In all learning processes there is theory and there is practice. Each is dependent upon the other: they should go hand-in-hand. The business of the author and teacher is to present theory; practice is up to the student. In the classroom the instructor can dictate to his students the kind and extent of practice he considers necessary; on the pages of a book he can only advise.

So, I advise the serious student of perspective to spend a great deal of time putting into practice the procedures demonstrated on these pages. He will need a lot more than the reading and understanding of the theory that he will find set forth in this book. He will need practice, and plenty of it. One acquires skill in drawing only by drawing, drawing, drawing and more drawing.

By way of emphasizing the effectiveness of concentrated practice, I am tempted to offer my own learning experience during my first six weeks of art study in The Massachusetts Normal Art School in Boston (now the Massachusetts School of Art).

The first day of school we were ushered into a large studio, in the center of which was a disordered pile of wooden grocery boxes of

Advertising drawing by Eric Fraser for the American Rolex Watch Corporation. A meticulously accurate drawing was required for this particular type of advertising illustration.

assorted shapes and sizes. Chairs and drawing tables were arranged in a wide circle around these uninspiring models. We were directed to draw the boxes. That was our only instruction; we were given no perspective theory, no hint of any kind of procedure.

We assumed that this exercise was merely a device to keep us occupied during the confusion of the opening day, and we looked forward expectantly to the morrow when something more exciting would be forthcoming, perhaps drawing from a living model. Imagine our dismay to find the situation unchanged except that the boxes had been knocked about a bit. We were told to draw them in this new arrangement. The next day it was the same, and the next. Sometimes each drawing was limited to an hour, sometimes to two hours. A monitor was chosen to rearrange the boxes at stated intervals.

This went on for six weeks without any theory whatsoever! We were told nothing about foreshortening or about convergence of lines; we were merely instructed to draw what we observed. The accuracy of our observation, I should explain, was checked and corrected by the instructor who admonished us to use our eyes more expertly. At the end of six weeks we were finally taught the scientific facts of perspective appearance.

When, years later, I began teaching perspective at Pratt Institute, I remembered this grueling and uninspiring six weeks, and I was critical of the method. I reasoned that it would have been better had we, at the outset, been given some theory that would have warned us what to look for as we drew those rectangular forms day after day.

I soon changed my opinion. I discovered that my own students very readily mastered the theory I was offering them, but still they couldn't draw. That was because they lacked the very attitude that was forced upon me by that six weeks' grind which taught me so well how to use my eyes. I came to the conclusion that theory and practice should be mixed in the proportion of 1 part theory to 50 parts practice, and I suggest to the reader that this premise be kept in mind.

Much drawing from objects without dependence upon theory cultivates the habit of three-dimensional thinking. One acquires the *feeling* of form: the feeling of lines and planes actually receding and not merely fooling the eye by their direction or shape on the paper. The professional artist forgets the surface of his paper—the picture plane—as soon as he begins to draw or paint upon it. When he sets down lines or masses to represent distance he actually thinks and feels distance. He projects himself right through the paper, figuratively, into a limitless beyond.

In drawing the outlines of those boxes as they *actually looked* in relation to each other, rather than trying to determine the convergence of their lines by considering how they *ought* to look (according to the vanishing points of perspective theory) we youngsters were getting just the kind of training needed to develop the sense of "form in space," without which no one ever becomes a good draftsman.

I make a good deal of this at the outset because the beginner does not realize how much practice he needs in drawing from objects. He is likely, especially when a book is his instructor, to believe that the theories set forth therein are his salvation. He does not fully appreciate the truth that all theory can do for him is to offer certain mechanical aids to his own observation and his own skills. Certainly he can do without theory better than he can dispense with practice.

Today the illustrator makes extensive use of photography in his work. And photographs of just about everything under the sun are available for his use—even for copying, if he chooses. Does he need an extensive knowledge of perspective, without which artists in pre-camera days were helpless?

There are many occasions, it is true, when he can and does literally copy his subject from photographs; but the present-day illustrator still needs as much skill in perspective as ever. Fred Ludekens once made many illustrations for Hiram Walker whiskey. These involved the drawing of innumerable barrels in all sorts of positions. Ludekens thought his assistant, with photographs before him, might relieve him of the tedium and time involved; in the end, Ludekens had to draw the barrels himself.

As a teacher at Pratt Institute, I asked to have my first perspective course labeled, *Structural Perspective*. That was to emphasize the necessity of developing a structural sense, an engineering sense that enables an artist to analyze every object, no matter how intricate, in terms of its simple geometric basis.

The development of this analytical skill is really the most important task before the student of perspective drawing. No matter how thoroughly conversant he may be with the facts of perspective appearance, he will be quite incompetent without a large degree of this engineering skill. Many problems that will seem very puzzling to the uninitiated call for some very keen detective work, even by a mind that is trained in a mechanical as well as a freehand approach.

6 *Preliminary drawing by Albert Dorne for his*
illustration in color for Collier's.
Note the meticulous drawing of every detail,
demonstrating this master's amazing knowledge and facility as a draftsman.

This brings us inevitably to the use of mechanical *views*—the customary approach of engineers and architects. These include top, front, side and sectional aspects of the subject which supply information that is indispensable for much illustrative drawing. To deal with this constructive phase of our work we need to make use of at least elementary instrumental drawing. And of course there are occasions when the illustrator has to resort to somewhat involved instrumental strategy. Such occasions may be the rendering of a factory interior or the nave of a cathedral, projects that involve knowledge of instrumental perspective that can be found only in books wholly devoted to that subject.

It will of course be understood that no competent illustrator has to follow the mechanical procedures that are here presented for purposes of instruction in the solution of many problems. Such, for example, as those demonstrated in the chapter on Shadows, and in the analysis of Peter Helck's drawing. But it goes without saying that the procedures involved are not only thoroughly understood by the illustrators but that they are actually in operation—at least in the subconscious mind. Just as a skilled musician has long since mastered the elements of his craft and can concentrate on the purely creative aspect of his art, so the perspective procedures of a professional artist's work become very nearly automatic.

There is such a phenomenon as "photographic vision." By this I mean the gift possessed by a few artists of just naturally knowing how to draw anything correctly without recourse to the kind of thinking and analytical study here demonstrated. This however is a rare gift; it is one that would better not be counted on by the student.

I believe the most valuable contribution of this book will be found in the study of pictures by prominent illustrators reproduced on the following pages and accompanied by analytical diagrams that demonstrate the solutions to many different perspective problems. These examples reveal the kind of resourcefulness and the graphic strategy that enter into the illustrators' art.

It is said that Paolo Uccello (1397-1475), the Italian painter, was largely responsible for perfecting the science of perspective. At any rate he was hypnotized by it and, according to Vasari, he begrudged time for sleeping and eating. He neglected his painting seriously and when his wife remonstrated, he would only reply, "Oh, this delightful perspective."

Of course I do not anticipate that my book will infect any readers with that degree of fanaticism, but I do hope that it will help to make the subject as pleasurable as it has been to me and to innumerable students. For, when the study of perspective is given the right approach, it can be as fascinating as crossword puzzles or other games that challenge the wit and stimulate the intellect.

Ernest W. Watson
January 1955

MATERIALS AND PROCEDURES

Although we are dealing with freehand perspective in this book, it will be necessary—as explained in the introduction—to use some of the procedures of *instrumental* perspective in the development of our experiments. Hence, the student should be supplied with the following minimum items of equipment.

A drawing board about 16 by 24 inches is recommended. A piece of illustration board the same size, tacked to one side, will give a pleasanter surface on which to work; and when drawing on tracing paper, the white illustration board underneath will be especially appreciated.

Drawing paper 16 by 12 inches or thereabouts is recommended for many drawing exercises. Larger sheets will sometimes be necessary, as smaller drawings—particularly when instrumental work is involved —will not be so accurate. The smaller the drawing, the greater the probability of inaccuracy.

A T-square of good quality, and 45 and 30-60 degree triangles—all of the transparent type—are essential. Two brass-edged rulers, one 24 inches long, a draftsman's compass and a pair of dividers will suffice as a minimum instrumental outfit.

When making instrumental diagrams, pencils with leads of hard degree are needed—H or 2H grades. These should be sharpened with a knife to points much longer than are produced by mechanical sharpeners. The leads should be kept well-pointed during all instrumental work, in order to avoid inaccuracies that would invalidate the whole procedure. For free sketching the softer leads will be preferred.

A large pad of tracing paper (about 19 by 24) is indispensable. Get samples from your dealer and select the most transparent sheet. There is a wide range of transparency in tracing papers. The student often will want to lay the transparent sheets over photographs and reproductions of artists' work, in order to analyze them by tracing the converging lines and extending them until they find their vanishing points. In this way much will be learned, not only of natural appearances as recorded by the camera but of illustrators' strategy in changing the rules to meet the needs of special situations. More about this later.

Many times, in making these analyses, it will be found necessary to fasten several sheets of paper together with scotch tape in order to secure a large enough area for the location of vanishing points which may be some distance away from the picture on either side. In this event, a yardstick may be substituted for the ruler in drawing the converging lines. When the vanishing points are found to be even beyond

7

Wire

8

Template

T-Square blade
reset so that
one edge is in
center of stock

10 9

11 12

the edges of the drawing table, the drawing can be laid on the floor and the lines projected by means of strings or threads extending from pins stuck in the picture, as shown in fig. 7.

In such a case we might assume that the illustrator who made the original drawing established his far-flung points by the same method. However, the chances are that once he had established his vanishing points with strings from two converging lines on each side, he resorted to the following device to get directions of all other converging lines without actually carrying them out to the far-flung points.

Extending a very thin wire—string is unsuited because it stretches—from pins stuck in at the vanishing points (already located, as in fig. 7) and attaching the other end to pencil points, arcs are inscribed on the drawing board as shown in fig. 8. (Good wire, as fine as thread, comes on spools.)

Templates are then cut with a sharp knife or razor blade, after having traced the arcs made on the drawing board and transferred them to thick cardboard. These templates are tacked firmly to the drawing board so that the arcs of their curved sides coincide with the arcs drawn by the wire compass demonstrated in fig. 8. Now the blade of a T-square placed against the curved side of a template (fig. 9) will always radiate from the vanishing point as it is moved along the arc; that is, its *center line* will. All one needs to do is to remove the blade—by removing the screws—and reset it on the stock so that one edge will be centered on the stock, as seen in fig. 10. Of course the blade must be set at exact right angles to the stock. By moving the T-square back and forth along the arcs, the direction of any line in the perspective drawing can be quickly and accurately drawn.

When a vanishing point is on the drawing board, a pin stuck upright at the vanishing point (as in fig. 11) will facilitate the drawing of converging lines. The straightedge can be placed against the pin and swung at any desired angle.

Fig. 12 demonstrates how strips of heavy cardboard, cut as shown, can be attached by pins to the vanishing points and used in place of the straightedge. Note that the pinhole in the strip must be in line with its drawing edge.

In fig. 13 we see another device for finding correct line directions when one or both of the vanishing points is beyond the edge of the drawing board. The right VP (vanishing point) is within range; the left VP is far out of bounds since the front lines of the cabinet are nearly horizontal.

We extend the vertical line of the nearest corner (1-3) upward to the eye-level (4). At any distance beyond the object at the left (the further the better) we drop a vertical from the eye-level to converging line (A)—whose direction has been determined freehand. This ver-

13

tical (1A-4A) is shorter than the nearer vertical 1-4, but if it is divided proportionately into the same divisions as 1-4 we have points through which converging lines would pass on their way to their vanishing points far to the left. Thus the top of the cabinet (3) is half the height of 1-4. On the 1A-4A line we mark off a point (3A) halfway up that line. Point 2 on the cabinet is one-quarter the height; on 1A-4A we give 2A its corresponding position. Any number of measurements on 1-4 can be duplicated proportionately on 1A-4A.

A camera and a projection machine are indispensable tools in the contemporary illustrator's equipment. Still more indispensable is such an inventive faculty as Frank J. Reilly brings to the solution of many of his illustration problems, of which the subject of this demonstration is an example—a picture of a marshalling yard, which Reilly painted for a Pennsylvania Railroad advertisement.

The picture illustrated the catch line, "An aircraft carrier goes by rail, before it goes to sea." It dramatized the part the railroads play in transporting material for the building and outfitting of a "flattop."

It was specified that a certain number of freight cars should appear in the picture—not as simple a result to achieve as one would imagine, says Reilly.

After futile experiments with pencil sketches in an effort to include the required number of cars, Reilly went to the lumber yard and brought back to his studio an armful of wood strips approximately one inch square in section. Upon these he marked off car lengths, carefully proportioning the lengths to the widths in order that his models would be in correct scale. Then he laid the strips on the floor in parallel rows to represent freight trains in a marshalling yard (fig. 15).

Reilly mounted a stepladder with his camera, and counted the number of "cars" that appeared upon the ground glass within a vertical mask that he had carefully cut to the proportion of the advertisement. Experimenting with the distance of his camera from the models, he soon discovered the position from which to take a photograph that would include exactly the specified number of cars, and allow for a few locomotives and some empty track.

He pasted the 3¼ x 4¼-inch print that resulted from this process upon a large sheet of paper, tacked to his drawing board, and—projecting the converging lines of the print—located the three vanishing points. The photo print was so small that all three points fell within the area of the drawing board (fig. 16).

From each vanishing point he then swung an arc on the paper, near the edge of the photographic print, as illustrated (fig. 16).

The next step was to enlarge the picture to the size of the intended painting. He did this in the following way. He made a photograph of the photo print *also* the paper with the arcs upon which the print was mounted; and, from the film, projected all onto the surface of

REILLY

15

17

18

16

14

20

*Advertising painting
for the
Pennsylvania Railroad
by Frank J. Reilly.*

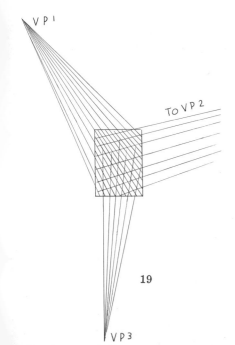

19

his paper (fig. 17). He then traced the main lines of the car models on the projected enlargement with his pencil, tracing the arcs as well.

On the enlarged drawing (thumbtacked to a large drawing table), templates cut of thick cardboard were tacked, their curved edges identical with the arcs of the projected enlargement (fig. 18). The T-square, traveling along the curved arcs of the templates as shown, served for all converging lines, many of which, in addition to those of the photographic print, were needed for the detailed drawing. Note, however, the necessity of resetting the blade of the T-square so that one edge of it bisects the stock and becomes what otherwise would be the center line of the blade.

The lower vanishing point (fig. 19) is located in a vertical that passes through the vertical lines of the picture—quite near its left edge. Study the chapter on three-point perspective in connection with this, pages 114-127.

The advisability—indeed the necessity—of drawing from models cannot be overemphasized. For flat models (21 to 28) use a heavy cardboard that will not warp. The heavy cardboard will not do for three-dimensional models that have to be scored, folded and assembled. For these, select a reasonably heavy bristol board that is rigid enough not to buckle and warp, yet is easy to work. A little experimenting with papers will reveal the most suitable one.

If the flat, geometric models are used constantly by the student the correct drawing of these basic forms will soon become second nature. Take the triangle, for example. This figure, as demonstrated on later pages, can be drawn quite easily by semi-mechanical procedure; but mechanical means can often be dispensed with by the student who with sufficient practice has acquired an authentic visual concept through practice drawing from the model (fig. 24). It is safe to say that one who makes 50 *careful* drawings from this model, turned in

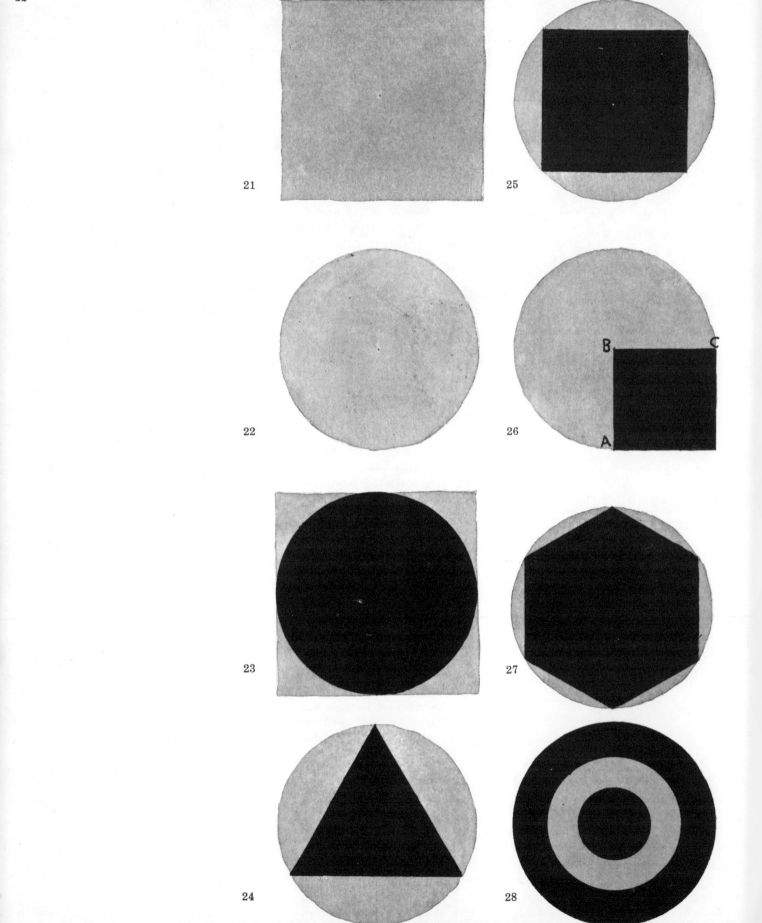

all possible angles and placed at different heights in relation to the eye, will have acquired a knowledge of this figure's appearance that will serve him well in years to come.

The same can be said for models 25, 26 and 27; especially fig. 26. The reason for this will be apparent later on when it will be seen how important it is to know how to relate correctly the right angle (ABC) to the circle seen in perspective (an ellipse).

The illustrator often has the problem of drawing several circular objects that are lying on the ground. A splendid exercise as training for this kind of assignment is drawing from dinner plates or phonograph records arranged on the table or floor. For some drawings use plates of the same size, for others select plates of different sizes.

If drawing these models seems to be tedious exercise—comparable perhaps to the pianist's five-finger exercises—the student who really wants to learn how to draw will attack them eagerly since they assure greater facility and authority in all subsequent work for the rest of his life.

A four-inch model of a cube is easily made from stiff paper (see diagram on next page). After the flat pattern has been cut out—a razor blade and brass-edged ruler will do this best—the parts marked for folding should be scored. Scoring can be done with a letter-opener or similar instrument. Fold so that the scoring is on the outside of the model. Transparent scotch tape is ideal for securing free edges. Before folding, inscribe a circle on at least one side and blacken it with india ink. It is not necessary to make a paper model of a cylinder—though that is relatively simple—because cylindrical cans and boxes of all shapes and sizes are available in the kitchen.

The cone can be easily constructed as indicated on the next page. After the base has been trimmed level (at right angles to the altitude) a circular piece of heavy cardboard can be fitted to it and secured with scotch tape.

Fig. 31 illustrates a model that is very important; a rectangle—preferably a square—attached to a cylinder. This is another model that ought to be drawn many, many times, turning it in all positions. The importance of practice with the model will be evident in numerous problems encountered in this book.

Sometimes special models like that pictured in fig. 33 are of great help. The aim of such models is a geometric analysis of the object rather than its facsimile. An analytical model is one which represents the simplest geometric forms from which the object can be developed. Oftentimes the most successful model is one which least resembles the object, thus model 33 gives no hint whatever of the object for which it was made—the wagon wheels (fig. 36).

Another word about tracing paper. Illustrators make extensive use of it. They often correct a first drawing on a sheet of overlaid tracing paper. A third or fourth correction is frequently made in this way. The final drawing is then transferred to illustration board for rendering in any required medium.

29

34

31

33

36

30

32

35

¼

12

16¼

¼

Good transfers can be made by blackening the back of the tracing paper with a 6B pencil and rubbing the tone smooth with the fingers or a wad of tissue paper. Carbon paper is not practical because the carbon line is hard to erase. A sharply pointed hard lead is used to go over the lines of the drawing in making the transfer. If such a transfer is carefully made, with sufficient pressure, transferred lines will be so black and definite that it may not be necessary to go over them with pencil or ink in order to strengthen them. Albert Dorne paints colored inks, which are transparent, right on top of such a tracing without touching the transferred lines. In the reproduction they appear to have been made with india ink. Another advantage of working on tracing paper is the possibility of studying the drawing in reverse. Errors are often detected—and corrected—in this way. Studying the drawing in a mirror gives the same result, although without the same ease of correction.

It goes without saying that those who draw a great deal from objects, indoors and out, will make the most progress. A certain amount of drawing from photographs is recommended too. These will involve subjects presenting structural problems that otherwise may not be brought to one's attention. But, it must be realized, photographs are often distorted impressions, quite unlike the images the same scenes would produce upon the retina of the human eye. Thus all photographs should be questioned in the light of what is demonstrated on the following pages, as well as from one's own observation of things seen and experienced. Comparisons of photographic effects with illustrators' drawings will prove interesting.

It is suggested that the student make a file of pictorial scrap illustrating the points covered in the various chapters. For example, when working in the cylinder chapter, collect as many pictures of cylindrical objects as possible. Analyze them on tracing paper overlays. This is equivalent to enlarging the scope of the book and extending the opportunity it offers for study. Some may prefer to paste such scrap in a loose-leaf notebook, along with analytical studies of the pictures.

The making of such picture collections will do more than anything else to make one "perspective conscious," to cause one always to be on the lookout for interesting applications of the principles being studied, to observe and understand, not merely to see.

chapter ii

THE STRUCTURAL APPROACH

It will help the drawing student if he thinks of himself as a builder or a structural engineer. While he does not handle wood, steel, or concrete, with his pencil he does construct on paper the forms created by these materials. The more he can develop his *engineering* sense, the surer and speedier will be the growth of his power as an illustrator.

Illustrative skill involves considerably more than the training of the eye and hand to see and record the correct appearance of things observed, essential as that is. There are those who can make reasonably good drawings of things they are looking at, but who are lost when they try to construct objects "out of their heads." They have a photographic eye, but they lack imagination.

Imagination, as it relates to our problem, is the faculty of comprehending the structural basis of all objects. It is the ability to analyze objects—no matter how complicated or cluttered with detail—in terms of the simplest geometric forms to which they are related: the cube, the sphere, the cylinder and the cone. It is the ability to see around and through objects. The illustrator must possess an x-ray vision; for him there can be no invisible lines. Like the engineer he deals with plans and elevations; like the mechanical draftsman he develops the habit of dealing with mechanical views—top view, side view, front view, and sectional view. These views give him information needed to clarify his problem. This structural sense is his very first need; without it, knowledge of perspective principles will not amount to much.

I used to send my students out with their rulers and notebooks to get structural facts of such objects as letter-boxes, furniture, the concrete mixer at work on the street, a wheelbarrow, the newsdealer's booth on the corner. They came back, not with perspective sketches of these things but with top views, front views and side views, together with their measurements. From this data they made perspective drawings in the classroom.

Such exercises are a means of developing one's imagination and an engineering sense. They constitute the structural approach. The student will do well to follow this prescription for basic training. This kind of study of simple objects such as those mentioned will provide the right habit of approach to all problems, no matter how complicated they might seem to be.

40

41

42

37

"Safety Poster."

38

39

Let us see how this structural approach applies to a few specific problems. Take the elementary problem of a ladder leaning against a building.

In the City Safety Council poster the painter is warned to set the ladder at a safe angle. The artist, in drawing it, needs to "watch the angle" in a different way. He has to visualize the ladder as one side of a triangular prism pushed against the wall. Otherwise his drawing is guesswork. There is no other way for him to test his drawing.

In fig. 38 we see the triangular prism correctly drawn, its base line AB parallel with the sill line CD and converging with it to the right vanishing point. (See Chaps. IV and VI for instruction on convergence of parallel lines.) Hence we know that the foot of the ladder rests where it should on the ground. In fig. 39 the error is obvious; the ladder rests in an impossible position, since AB is not parallel with CD as it should be.

The engineering approach has to be applied to the drawing of as simple an object as a mallet. The top and side views in fig. 40 tell us that the handle is at right angles to the cylindrical head, and that we find point B on a line extending from A into the cylinder's axis (D).

Getting the direction of the handle is the first step in the perspective view. This is best done by drawing imaginary line AC, which is directly under the handle on the ground. It is much easier to find point A by this indirect approach. Line AC must, of course, be at right angles to the cylinder's axis. There is no mechanical means of establishing this

A drawing by Thomas Rowlandson.

angle; it is a matter of freehand judgment. Whether the correct line is the one shown in fig. 41 or whether one of the dotted lines is more accurate is something that can be known only through the artist's experience. It involves the ability to draw a right angle in any position in relationship to the cylinder in certain positions. (See fig. 31, page 24.) The acquisition of this ability is of first importance to the student. Once line AC has been established, the rest is mechanical procedure. We have to cut a section, as it were, through the cylinder at its center (fig. 42) in order to find point B.

The analysis and procedure in the hinged box cover (fig. 43) is one that is applied to many situations, of which the open door (fig. 44) is perhaps the most common.

The trained artist always looks for a simple geometric basis for every object he draws. Thus the scotch-tape holder (fig. 45) obviously is a combination of two cylinders with a cylindrical hole in the larger one.

The proper way to draw the coach is shown in the analytical diagram in fig. 46; a large cylinder for the rear wheels and a smaller one for the front ones. It is natural and helpful to sketch an ellipse as a guide for the drawing of the curved body line, although only an arc of the ellipse is involved. Thomas Rowlandson, an 18th century English artist, drew the accompanying coach. It is strange that an illustrator who was such a perceptive observer and delineator of life and character should have completely failed in the drawing of the wheels of his coach.

28

48

52

49

50

51

53

55

T O P
V I E W

FRONT VIEW
56

SIDE VIEW
57

54

*The drawing in this advertisement
for Thomas Register
was made by illustrator W. N. Hudson.*

Many times the solution of a problem is facilitated by imagining that the object is carved out of, or contained within, geometrical solids. The lawn sweeper (fig. 48) might be analyzed in this manner. Studying its side view (fig. 49) we discover that the handle, extended to the ground (A) forms a triangle ABC. If, then, we draw in perspective a triangular prism (50) of correct proportion, we have a basic geometric form which, if accurately drawn, solves our problem.

In order to draw that triangle in correct proportion we have to have some way of measuring it. In the next chapter it will be seen that we measure things in perspective by means of the square. Now we see in fig. 51 that the rectangle (ABCD), which encloses the triangular form, is wider than it is high. Fig. 51 demonstrates that it is one square (AEGD) and one quarter in width. If, then, we construct a square (AEGD) in perspective (fig. 52) and add a quarter square to it we shall have a rectangle of correct proportion within which our triangle is inscribed. The important thing here is to estimate properly the square, a simple matter for one who, through much practice in drawing squares, has acquired this facility.

In fig. 53 we draw the wheels, noting, by referring to fig. 49, that they are of such size and in such position on the handle AC, that they just touch a vertical at A. The completion of the drawing from this point on is merely a matter of detail.

HUDSON

Now consider illustrator W. N. Hudson's problem when he was asked to make the drawing of scales for the Thomas Register advertisement. For this subject he did not have a model from which to draw; probably all he had to go on was a rough layout made by the art director to indicate what was wanted—or perhaps just a verbal suggestion. So he had to *build* the scales; that is, build them with his pencil.

In the first place, he had to design the scales much as an industrial designer would do. This necessarily involved thinking about the object in terms of "views," in order to establish the facts of its construction in top, front and side view sketches (see figs. 55-57). Probably he made several such trial sketches, varying the proportions of the box, and varying the size, the height and the position of the pans in relation to the box. Doubtless he tried out these various designs in perspective sketches before finally deciding on the one to use.

58

59

60

61

From the first, he would have automatically analyzed the problem as a box set down between two cylinders (fig. 58).

Next, he would sketch the *plan* of the object in perspective as in fig. 59—two circles with a rectangle between. Working from plans in this way is common perspective practice. This is an important step and it involves expert knowledge of what these geometric figures would actually look like in perspective. A beginner attempting this would do well to test his drawing by reference to models. (Two cardboard disks or dinner plates and a rectangle of cardboard will serve nicely.)

Next (fig. 60), the box is drawn in correct proportion to the design decided upon, and a vertical plane (ABCD) is passed through its center to establish the height of the two cylinders whose top circular planes will be drawn—as ellipses—on the diameters, XY. The arms connecting the pans with the box will be drawn in this vertical plane.

All that remains now is to draw the top ellipses of the cylinders.

It is not to be supposed that any professional illustrator would carefully go through steps similar to those outlined in this chapter for simple objects which he could draw almost automatically. But the kind of thinking here demonstrated applied to more complicated situations is indeed common professional practice.

55

TOP VIEW

FRONT VIEW
56

SIDE VIEW
57

54

The drawing in this advertisement
for Thomas Register
was made by illustrator W. N. Hudson.

Many times the solution of a problem is facilitated by imagining that the object is carved out of, or contained within, geometrical solids. The lawn sweeper (fig. 48) might be analyzed in this manner. Studying its side view (fig. 49) we discover that the handle, extended to the ground (A) forms a triangle ABC. If, then, we draw in perspective a triangular prism (50) of correct proportion, we have a basic geometric form which, if accurately drawn, solves our problem.

In order to draw that triangle in correct proportion we have to have some way of measuring it. In the next chapter it will be seen that we measure things in perspective by means of the square. Now we see in fig. 51 that the rectangle (ABCD), which encloses the triangular form, is wider than it is high. Fig. 51 demonstrates that it is one square (AEGD) and one quarter in width. If, then, we construct a square (AEGD) in perspective (fig. 52) and add a quarter square to it we shall have a rectangle of correct proportion within which our triangle is inscribed. The important thing here is to estimate properly the square, a simple matter for one who, through much practice in drawing squares, has acquired this facility.

In fig. 53 we draw the wheels, noting, by referring to fig. 49, that they are of such size and in such position on the handle AC, that they just touch a vertical at A. The completion of the drawing from this point on is merely a matter of detail.

HUDSON

Now consider illustrator W. N. Hudson's problem when he was asked to make the drawing of scales for the Thomas Register advertisement. For this subject he did not have a model from which to draw; probably all he had to go on was a rough layout made by the art director to indicate what was wanted—or perhaps just a verbal suggestion. So he had to *build* the scales; that is, build them with his pencil.

In the first place, he had to design the scales much as an industrial designer would do. This necessarily involved thinking about the object in terms of "views," in order to establish the facts of its construction in top, front and side view sketches (see figs. 55-57). Probably he made several such trial sketches, varying the proportions of the box, and varying the size, the height and the position of the pans in relation to the box. Doubtless he tried out these various designs in perspective sketches before finally deciding on the one to use.

58

60

59

61

From the first, he would have automatically analyzed the problem as a box set down between two cylinders (fig. 58).

Next, he would sketch the *plan* of the object in perspective as in fig. 59—two circles with a rectangle between. Working from plans in this way is common perspective practice. This is an important step and it involves expert knowledge of what these geometric figures would actually look like in perspective. A beginner attempting this would do well to test his drawing by reference to models. (Two cardboard disks or dinner plates and a rectangle of cardboard will serve nicely.)

Next (fig. 60), the box is drawn in correct proportion to the design decided upon, and a vertical plane (ABCD) is passed through its center to establish the height of the two cylinders whose top circular planes will be drawn—as ellipses—on the diameters, XY. The arms connecting the pans with the box will be drawn in this vertical plane.

All that remains now is to draw the top ellipses of the cylinders.

It is not to be supposed that any professional illustrator would carefully go through steps similar to those outlined in this chapter for simple objects which he could draw almost automatically. But the kind of thinking here demonstrated applied to more complicated situations is indeed common professional practice.

THE SQUARE AS A UNIT OF MEASURE

An object must be measured before it can be represented accurately in a drawing. This is as true in freehand sketching as in instrumental drawing. In instrumental work the exact dimensions must be known, the lengths of all lines in feet and inches being required before the draftsman can make his drawing either full size or to scale.

The artist making a freehand drawing must *measure* the object just as carefully, but in an entirely different manner. He does not ask to know the height, in feet and inches, of the building he chooses to sketch; nor is its exact width important to him. But he must know the *relative* lengths of these lines—the *proportion* of one to the other. *Proportion* is, therefore, his principal concern in the analysis of his subject. He must have some infallible method of measuring proportion.

The study of proportion has not been included in books on perspective, but it is so inseparably related to perspective in practice that, logically, it should be a part of any program of drawing instruction.

The student is frequently seen holding his pencil at arm's length and squinting his eyes as he moves his thumb along it in an effort to measure the lengths of lines. The amateur feels confident in the efficacy of this device. If the proportion of his drawing is criticized he is likely to say, "It *must* be right; I measured it." This method of measurement is dangerous because it convinces the beginner he is right when he is probably quite wrong. Pencil measurements are unreliable. An inch, measured off on the pencil, represents an eight-foot window sill across the street. To measure exactly is almost impossible: the hand is unsteady; it unconsciously moves closer to the eye at times; the body moves forward or backward slightly; the pencil may not be at right angles to the direction of sight. Any one of these imperfect conditions can account for serious errors when ⅛ inch on the pencil represents a foot of the line measured. In my classes, pencil measurements have always been *taboo*.

How then shall the object be measured? In the first place there must be a *unit of measure*. All scientific measurements are based upon some logical unit of measure. For the purposes of the artist in measuring proportion, the obvious unit of measure is the *square*. We can say, truthfully, that the square is the *only* possible unit of measure, whether or not the object is foreshortened.

62 63 64 65

Draw in outline a 2-inch square in india ink on a small piece of window glass or transparent plastic. Hold this measuring glass up and, closing one eye, look through the square at the building across the street.* By moving the glass nearer or farther away, the size of the square will conveniently appear larger or smaller and so will serve as a measure for large or small areas. Remember that we are measuring *areas,* not lines.

If you were thus studying the proportion of the gate (fig. 62), you would find your square exactly fitting the gateway. The square would enclose the chest of drawers (fig. 63). The outlines of the mantel (fig. 64) would not fit in your square, but you will note that the fireplace itself is a square. In making your sketch of the mantel you would, therefore, start your layout with the square opening, it being a simple matter to relate the other dimensions to it when the square is indicated on the paper. Similarly in fig. 65, you would find a square at once, and readily observe that the balance of the ornamental iron screen above takes up one-half of a square.

Imagine now that you are in the garden about to sketch the garden-house (fig. 66). You find that the square exactly encloses the entire structure, except for the chimney and steps. And you note that the eaves' line falls halfway down the square. The rectangular portion of the ell does not quite fill the square—the dotted line in fig. 68 indicates the top of the square—but its window opening just fills your square measure, as do the ends of the entrance steps (fig. 69).

66 67 68 69

The drawings on pages 32 through 35 were made by the author in a series of advertising drawings for Eldorado Pencils. Courtesy Joseph Dixon Crucible Co.

*I have in my possession a square reducing glass, across the face of which are engraved lines that cross each other at right angles, forming a series of smaller squares. When viewing objects through this glass they are automatically measured in terms of the square. The glass is of French manufacture and so far as I know is unobtainable in this country.

Now measure the ballroom window (fig. 70). The shade is conveniently pulled halfway, making the measurement a simple matter.

Next let us study the Italian subject (fig. 72). As you move the glass about, letting the square play over the structure, the only square you discover is the entrance portico. This square is too small to help much in finding the proportion of the building. But, if by now you have become "square conscious," you will quickly discover that the right-hand line of the tower projected down through the building makes a square (A, fig. 73) which gives you the right start. Your measuring glass will certainly pick up the partly enclosed space B, which helps decidedly in sketching the tower. Play your square over the tower itself. Note that the top of the central window conveniently cuts off a square (fig. 73A). You readily estimate that the remainder is about one-third of a square.

It is always desirable to make the first measurement include as much of the area of the subject as possible. The garden-house (fig. 66) was entirely enclosed within our first square. The Italian subject (fig. 72) did not suggest an enclosing rectangle because of its broken contour. The square A was deemed a more practical measure as a basis for the sketch.

70

71

72

73

74 75 *Ernest W Watson* 76

The first glance at Coutances Cathedral (fig. 75) reveals the large square X. The upper portion of the building is not so readily measured, but, having the correct proportion of the lower part, it is easy to measure the tower masses. You can hardly fail to pick up square A, as your measuring glass moves over the facade. This is a very useful measurement. The structural lines of the tower practically cut the large square X into three equal vertical spaces, and B is close to being a square.

The square measurement units that were used to make illustrations 78, 81, 83 and 85 are shown in the drawings accompanying them.

The employment of the square in determining proper proportions will be found especially useful in memory drawing. If in memorizing an object to be drawn later we carry in mind a geometric framework based upon a reliable unit of measure, we can have greater assurance that our drawing will be a faithful illustration.

80 81 82

S. MARIA
DELLA SALUTE
Venice

These SQUARES
are quite obvious at
first glance

But a large
enclosing square
is desirable as a
first measurement

NOT QUITE
FILLING
A SQUARE

A LITTLE ABOVE
THE CENTER OF
THE SQUARE

77

WELLS CATHEDRAL

78

A
SQ. | A
SQUARE | A
SQ.

A
SQ. | A
SQ. | A
SQ.

79

The student will find that after studying proportion for some time with the measuring glass, he has acquired an accurate concept of the square and, dispensing with it, will discover that he has become "square conscious" and possessed with an infallible method of measuring proportion.

We have used architectural subjects only in these demonstrations but of course the procedure applies to all objects equally well, and the student is advised to practice measurements on all the common things that surround him in the home and on the street. Pictures in magazines make excellent practice material. They can best be analyzed by laying tracing paper over them.

Thus far we have used the square only to measure objects seen in front view, or elevation, where no foreshortening is involved. Can this unit of measure be applied to subjects seen in perspective, like the little country church (fig. 86)? It can.

83

84

85

86

87

This sketch shows the measuring glass being held *at right angles* to the direction of sight, resisting the tendency to turn it in the direction of the plane being measured. This of course is not a true measurement of the front of the building which is considerably wider than its height at the eaves: it merely tells us what the width of the façade—on our sketch paper—should be in relation to its height.

But fig. 87, where our square encloses nearly the entire structure (by bringing the glass closer to the eye), gives us a measurement we would do well to make at the beginning. Whenever we can enclose the whole object within the square, we have a convenient means of placing the drawing on the paper and blocking-out the main lines. Figs. 88 and 89 indicate still other measurements that are quite obvious.

Now as we have said, this procedure, although it is an aid in making our sketch, tells us nothing about the actual measurements of the subject itself. For that reason its usefulness is limited.

Suppose, for example, our task were to draw the church not from observation but from specific measurements: width 30 feet, depth 40 feet, height at the eaves 20 feet (fig. 90).

The long side is a rectangle twice as long as its height, or two squares. The width of the front is half as much again as its height, or a square and one half. How are we to measure these dimensions in perspective, on foreshortened surfaces?

The architectural renderer lays out his perspective drawing instrumentally and projects actual measurements; the illustrator's measurements have to be estimations, but if he knows what a foreshortened square looks like he will come very close to exactness in his freehand sketch.

The first step, then, in measuring the front of the church—after the directions of the converging lines has been indicated—(fig. 91) is to establish the estimated width (X) of a square (fig. 92) whose height is fixed at the corner of the building. How accurate is this figure? Is it a square?

90 91 92

88

89

Now it is easier, even for the practiced eye, to judge the foreshortened square when it is visualized as the face of a cube. So let us indicate the other visible face of the cube on the long side of the building (fig. 93). This face must be wider—in our sketch—than the other because, as the steeper convergence of the front lines indicate, the front plane is turned away from us at a greater angle and all horizontal measurements on it therefore are more foreshortened; hence, on the right side, less foreshortened and wider.

Even the beginner, who, before, might have been undecided about the X rectangle (supposed to represent a square) now sees at once that fig. 93 is far too wide to represent a cube and that X, consequently, cannot be a square. Fig. 94 certainly looks more like it and this cube will serve in establishing the widths of both front and side walls of the church. The church's dimensions can now be determined geometrically as shown at fig. 94.

Two distinct methods of measuring with the square have been demonstrated. One employs the square on an imaginary transparent plane (an actual piece of glass for the beginner) at right angles to the direction of sight; the other dispenses with the glass and uses the square in perspective. Which is better?

Each method has its value, but since the experienced illustrator always thinks of what he is drawing as three-dimensional, he usually makes his measurements in perspective. He never thinks of the flat surface of the paper upon which he is working; he is always projecting his image *through the paper,* as it were. To rely to any extent upon the methods demonstrated in figs. 86, 87, 88 and 89 is, for him, a rather artificial method; it contradicts his whole attitude of three-dimensional thinking. That is not to say that he never resorts to it by way of checking against his perspective measurements. Chances are that most illustrators do just that.

The student is advised to use both methods simultaneously. Until he has had much practice in drawing cubes and has learned unmistakably what a cube looks like under all conditions, he will experience much difficulty in perspective measurements.

93

94

95

THE PICTURE PLANE

Almost everyone, as a child, has demonstrated the function of the picture plane by tracing upon the windowpane, with wax crayons, the outlines of the house across the street. In his tracing, the child thus achieved a reasonably correct, if crude, perspective representation of the structure, provided the position of the eye was not changed during the drawing.

And so the picture plane can best be conceived as a sheet of glass through which the artist observes his subject and, in imagination, traces its outlines; the lines actually being drawn on a sheet of paper which thus takes the place of the transparent glass.

It should be said at the outset that for anyone who has much aptitude for drawing, the concept of the picture plane is wholly unnecessary in practice. It would not have been introduced into this book were it not useful now and then in demonstrating certain phenomena and various procedures otherwise difficult to explain. The person who draws naturally does not even think of a flat plane. To him the paper upon which he draws is not a flat surface: it is *space*. When he sets down lines to represent distance, his pencil pushes those lines right through the paper—twenty feet or half a mile. The retreating line reaching toward the horizon may be only three inches long on the paper, but to the artist it feels just as long as the street or the railroad track or whatever he may be drawing.

Hosts of artists have never given the picture plane a thought, and even children in their first drawings are able to think of the drawing paper as space rather than a flat surface.

So it seems very unwise to put too much stress upon the concept of the picture plane in teaching freehand perspective, although it is absolutely essential in instrumental perspective. An illustrator called upon to make drawings of buildings or other structures that demand accuracy of measurement must resort to the same kind of instrumental procedure that is employed by the architectural and engineering renderer. The student of freehand perspective who intends to become a professional artist will do well to consult a good text on instrumental perspective. Here, we can only indicate in the simplest diagrams the basic principles in instrumental procedure.

When we do think of the picture plane it is important to remember that it should be imagined at right angles to the central direction of sight, and that its position should not change in any given picture. That is the basic rule but there are exceptions to it, as we shall see.

TOP EDGE OF PICTURE PLANE

VP¹ D A a d B g c h e C E G H VP2

STATION POINT

VP¹ EYE LEVEL - HORIZON VP2

FRONT VIEW OF
PICTURE PLANE

X X

VP¹ HORIZON VP2

Y Y

SIDE ELEVATION B

97

The whole theory of scientific perspective is predicated upon the assumption that the direction of sight, hence the position of the picture plane, remains constant in the picture. The theory is consistent with photography, which records a wide-angle scene upon an immovable picture plane—the camera's plate or film.

But the human eye sees things quite differently. Its direction of sight is constantly shifting; it has to, because our eyes can focus only upon a single point at one time. As I write, I look down from my studio at the florist's window on the street corner. I am very conscious of shifting my gaze in trying to distinguish the various items in the window within the space of seven or eight feet. Automobiles not thirty feet from the store window, just around the corner on each intersecting street, are mere blurs. All that I can tell about them without perceptibly changing my direction of sight is their color and their general type—truck or passenger car.

Thus we see that an immovable picture plane violates the whole process of seeing. Yet, considering the inconsistency, it serves remarkably well provided the artist understands its inconsistency under certain conditions and knows how to compensate. The skillful artist is always taking liberties with scientific perspective, violating its rules for reasons of design or for a more truthful impression.

The diagrams in this chapter demonstrate the basic procedure of the instrumental method. In fig. 97 we look down upon the picture plane. Think of it as a large sheet of glass standing vertically on the ground. Seen from above its top edge would appear as a thin line. The gray rectangular form represents the plan or foundation of a building. It touches the picture plane at B. This is not necessary; it might be placed at a considerable distance behind the picture plane, but it is given this position here for a special reason that will appear later.

The "station point" represents the eye of the observer. It may be any distance from the picture plane according to the effect desired in the perspective rendering.

98

From the station point, lines are drawn to the picture plane parallel with the sides of the building, lines AB and BC. This means, of course, that the angle at the station point (shaded) is a right angle. These lines from station point to picture plane locate the two vanishing points and, as seen in our diagram, they are projected down for the perspective drawing in figs. 98 and 99.

It will be evident that the placing of the station point controls the perspective effect. The nearer it is, the more "violent" the perspective.

To avoid this and to get a more normal effect, the distance of the station point from picture plane can be increased. This automatically extends the vanishing points further to right and left because the station point angle (shaded) is always a right angle.

99

100

101

The station point also can be located laterally wherever desired. Its position taken here is purely arbitrary; it might have been any distance to right or left. Try moving the station point both laterally and more distant from the picture plane and see what happens. What does happen when the station point is close to the picture plane is seen in fig. 102, and in fig. 100 where we get violent and distorted images. The near corner of the rectangle in perspective (fig. 102) is a very acute angle, an effect never seen in normal vision. Experiment with a rectangle on the floor. It will be found that the near corner is always an obtuse angle; it can never be seen as an acute angle as in fig. 102.

Therefore it is usually advisable to locate the station point far enough away from the picture plane to avoid such distortion. That, as we have stated, will throw the vanishing points further to the right and the left, widen angle X (fig. 102) and give a normal appearance. There are times, to be sure, when the artist deliberately employs distortion for a good purpose, as in the Curare drawing on page 122. Indeed this is very commonly done.

Everyone who has used a camera is aware of what happens when the picture is taken close to the object, as was the case in photographing the Museum of Modern Art (fig. 101). The result of a close camera range like this is the same as that achieved in drawing when the station point is near the picture plane. Although it is an "unnatural" effect, we have become so accustomed to such photographic exaggerations that they are more readily accepted than formerly. If the camera had been at a great enough distance to give a more "normal" perspective to the museum building, the picture would have failed to show sufficient detail. The fact that but a little of the right side shows in the photograph is a compensating factor. Had it been standing alone, as in fig. 100, the distortion would have been more noticeable.

Having established our station point and vanishing points (in fig. 97), lines are drawn from the station point to the several corners of the plan (A, B, C, D, E, G and H in fig. 97). Think of these lines as beams of light that connect the eye with the object. Where the beams cut through the picture plane we have points *a, b, c, d, e, g* and *h* that, projected down to the perspective drawing in fig. 98, establish the correct relative dimensions of the plan in perspective. To fix our vanishing points in fig. 98, we have dropped verticals from the vanishing points—already established in plan (fig. 97)—until they meet the eye-level. The eye-level can be placed higher or lower than shown in fig. 98, according to the vantage point from which we wish to view the subject.

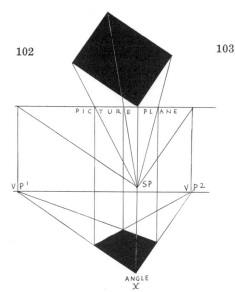

102 103

Now in practice one would erect the building directly upon the perspective plan (blacked-in) in fig. 98, and develop the entire drawing there. To simplify the procedure and avoid the confusion of a complicated drawing we make a separate diagram (fig. 99). The *a, b, c, d, e, g, h* points have been projected down to this diagram from fig. 97.

The height of the building and its smaller element (C, G, E, H in the plan) are indicated in the side elevation. Projecting horizontals from it to the perspective drawing we have points X and Y on the nearest vertical XB. These are the only measurements needed. When point Y is projected back to VP² on the horizon, it indicates the height of the small element.

As previously stated, the building touches the picture plane (point B) for a special reason. Had it been set back from the picture plane we could not have projected the vertical heights from the elevation (fig. 99)—which is drawn on the picture plane—to the building's near corner. In that case it would have been necessary to project either line AB or line CB in fig. 97 forward until it touched the picture plane, giving us a vertical line on the picture plane upon which we could measure heights. We could then project our measurements from the side elevation to that vertical line and project them back toward vanishing points, as we have done at Y (in fig. 99), to find the height of the small element. All vertical measurements have to be taken on the picture plane and projected back into the distance on the foreshortened planes.

Until relatively recent times the picture plane was invariably considered a vertical plane; no one thought of tilting it to look up or down at objects. But, of course, we do that constantly in viewing things that surround us. And, when we do, we see objects in 3-point perspective. There is convergence not only in their horizontal lines; the vertical lines converge as well—upward or downward as the case may be. A photograph taken with a tilted camera produces effects of 3-point perspective with which we are all familiar. This aspect is demonstrated in a later chapter, therefore we shall not discuss it at this point.

Now let us come back to the reference of a child making a perspective drawing on the windowpane of a house across the street. He would have learned, had it been pointed out, that any set of the building's lines which recede into the distance would, if continued, meet at a point. That point would be found to be on the exact level of the observer's eye on the window glass.

Hence the perspective fact, *all horizontal, parallel receding lines converge and meet at a point on the eye-level,* or at the horizon—which is the same thing.

VP 2

FAWCETT This is demonstrated in illustrator Robert Fawcett's drawing of the housewife standing at the old kitchen range (105). In that drawing there are four sets of parallel lines, hence there are four different vanishing points (VP[4] lies outside the page). The long lines of the stove, the lines of the wall against which the stove is placed and the short edges of the table (against the back wall) are all parallel to each other; therefore they converge to the same vanishing point (VP[1]) on the eye-level at the right. The short lines of the stove, the other wall and the long lines of the table constitute another set of parallel lines; they converge to VP[2], on the eye-level at the left.

The serving table, just behind the figure, is turned at an angle to the lines just mentioned. As demonstrated, its long parallel lines converge to VP[3] and its short ones to VP[4]. If this table were moved to the position indicated by the dotted rectangle, its vanishing points would have still different locations on the eye-level.

In this drawing the eye-level happens to pass through the eye of the cook. That is merely because the illustrator assumed that he was standing in the room as he drew and that his height was the same as that of the woman. Had he assumed a sitting position the drawing would have been as shown below. The horizon line would have dropped to his lower eye-level.

104

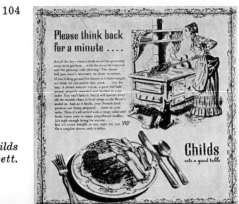

This drawing for an advertisement for Childs was made by illustrator Robert Fawcett.

105

106

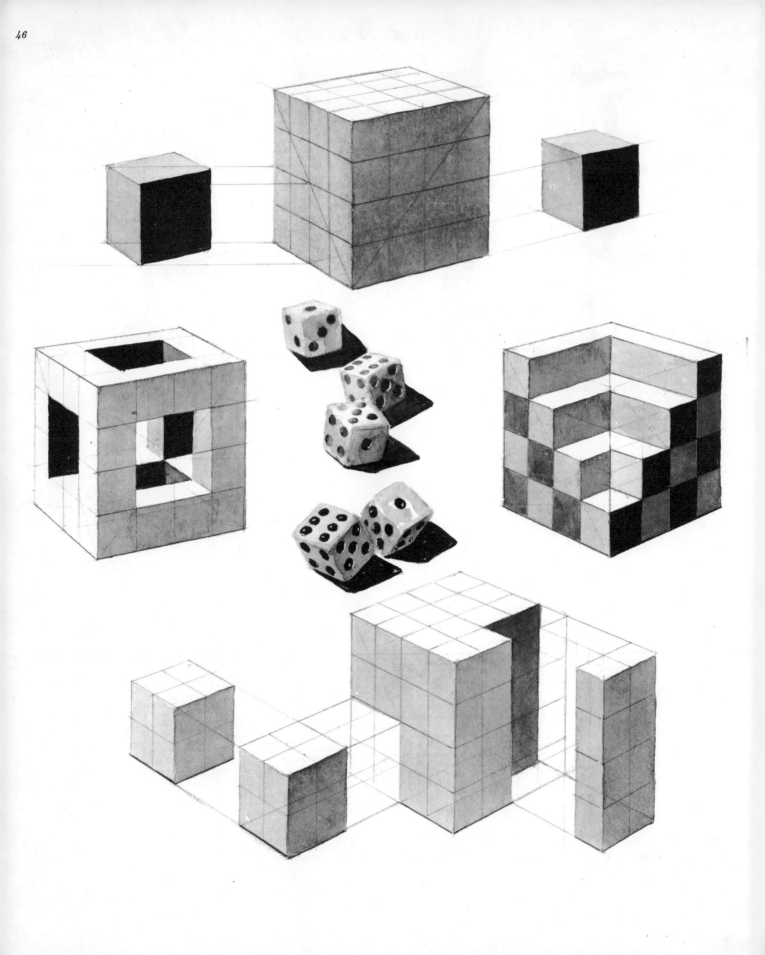

THE CUBE

It will be increasingly evident to the student that familiarity with the cube is extremely important in both simple and complicated structural developments. In later chapters we shall find ourselves needing great facility in drawing cubes when confronted by a variety of forms that can best be rendered by relating them to this basic geometric solid. In the chapter on the *circle,* for example, the cube helps us to determine the proportion of ellipses that represent circles in various positions.

So the student should be continually drawing cubes—with the model before him, of course—until he can almost draw them with his eyes shut.

On pages 38 and 46 there are suggestions for cube practice. Consider first page 46. Here we work with a cube that, when subdivided as shown, is made up of 64 smaller cubes. Before proceeding with the various arrangements—and others that will suggest themselves—be sure that your cube is absolutely correct to begin with. Drawings should be made at least one-and-one-half the size of those on the printed page.

First sketch the cubes freehand, drawing directly from a model of the cube. When the drawing looks right test it by extending the converging lines till they meet on the eye-level. Use T-square and triangles for these tests. It may be necessary to lay the drawing on another very large sheet in order to find the vanishing points at considerable distance from the cube. The lines extending at the right should, of course, meet at the same point; those at the left at another point on the same horizontal eye-level. When the converging lines have been corrected the question still remains: "Is it a cube?" It might be too narrow or too wide.

One way to check on proportion is to lay a windowpane over the drawing and, with an architect's ruling pen and india ink, trace the cube lines carefully. The glass surface is not easy to draw upon but it will actually take the ink. (You will need a brass-edged ruler.)

Now hold the glass at the side edges near the top so that it will hang vertically and *at right angles to your direction of sight* as you view the cube through it. You are really looking through the picture plane, and if your drawing is correct its lines will cover those of the model. If they do not, correct the drawing and test it again.

This may be a tedious business, for you may have to make several tests before you get a perfect drawing. But it is time and effort well spent. Many artists go through life making cubes too wide or too narrow because they never really learned what a square—hence a cube—looks like in perspective.

The student with a camera with a lens that will take close-ups will find it profitable to take many pictures of the cube in different positions. These photographs can then be used as a means for checking his drawings.

EYE LEVEL

A

C

B

D

E

20 INCHES

110

Now try doing a page of cubes like those on page 38. Of course it is not necessary to render the cubes in wash as shown but it is excellent practice and is more fun. Lamp black is diluted with water and applied with a No. 5 sable brush. If the cubes are first drawn in line on tracing paper, then transferred to a good sheet for the shaded drawings, the result will be better.

The cubes on the black background will give an even greater test of cube skill. The student may want to compose his own arrangement instead of copying the plate; but that is unimportant. It will not be practical to carry out these drawings instrumentally. This test throws one entirely upon his freehand judgment.

A day or so after completing them, look at your cubes critically with a "fresh eye." You will be certain to make some corrections. Do this for several days until you can no longer find fault with them.

When the cube is seen in direct front view, so only its front face and top are visible, the beginner finds it difficult to realize how greatly the top face is foreshortened; usually he makes it too wide from front to back, as at A, fig. 109. To appreciate the extent of the error in this figure we have only to project lines down from cube A to show how this figure would look (B) when seen at a lower level, where its proportion can be more accurately judged. Instead of a cube, we now see that we have drawn a rectangular solid more than five times as long as its square end (E).

The cubes C and D were drawn by the author from actual measurements taken in the manner shown in fig. 110. The cube D rested on a table just twenty inches below the author's eye-level and three feet away. Squinting along the edge of a ruler, the front to back width of its top face appeared to be slightly over one quarter the cube's height. The cube C rested on a shelf only eight inches below eye-level, hence its top face appeared much narrower.

If the cube had been nearer, the top face would have shown greater depth because the nearer to the eye, the more nearly one looks down upon it. This kind of meticulous measurement is occasionally advisable; it helps in educating the eye to such an accurate judgment that the use of the model can soon be dispensed with.

A number of elementary perspective facts are demonstrated in fig. 111. Cube No. 1, placed midway between its vanishing points 1 and 2 presents two equal vertical faces. That means that the diagonals AB and CD (dotted lines) are horizontal and the diagonals EF and GH are vertical.

No. 2 cube has been set off to the right so that its right vertical face is turned considerably more toward us; so much so that its long converging lines vanish at a point far off the page at the right, while those of the left face—turned sharply away—find a vanishing point not far to the left of the cube. Its AB, CD diagonals now are not horizontal; if carried out to the left, being parallel they would meet at a vanishing point on the eye-level far off the page.

No. 3 cube is one-quarter the size of No. 1, whose left face has been divided into quarters by the intersection of the diagonal line (AG) with a horizontal bisecting line from K. Note that although the small cube has not been turned—having merely been pushed forward from cube 1, as it were—its right face is wider than its left.

Note also the directions of the EF and GH diagonals of cube 3; they converge with the EF diagonal of the parent cube because those diagonals are actually parallel. That geometric relationship is often useful, as it was here in determining the location of the small cube's point F. Points E and G were found by projecting forward from O and P of cube 1. Next SO was projected forward, giving the correct width of the narrow face.

It will be seen that the further the cubes are placed to the left, the wider their right faces and the narrower their left. The opposite applies to cubes at the right of the center.

Incidentally, the drawing of cubes placed like 4, 5 and 6 offers a means of testing the accuracy of cube 1. If through error of judgment cube 1 had been made too wide, a cube in the position of 4, 7 or 8 might present a wide face actually wider than its height.

111

112

FORESHORTENING AND CONVERGENCE

I suppose it would be an unpardonable break with tradition not to use the railroad track to demonstrate the simplest of all perspective facts: the fact that objects appear progressively smaller as their distance from the eye increases—the railroad ties and the telegraph poles —and the fact that, therefore, the rails and the wires converge and (in a picture) come together at a vanishing point on the eye-level. The space between the ties and between the poles decreases progressively with the increase of distance.

The position of the observer in fig. 112 is in the center of the roadbed, between the tracks; and as he looks straight ahead toward the horizon (the level of his eye) all the railroad ties are at right angles to his direction of sight. That is the way they would look in a photograph. In one-point perspective all such parallel, horizontal lines in the subject (according to the rule) are represented by horizontal lines in the picture. There are exceptions, as we shall see.

When the observer steps off the tracks to the left of the roadbed and views the tracks from that position, what he sees is illustrated in fig. 113. The rails converge to a point at the left; and the ties, instead of appearing as horizontals, take a slanting direction and converge to a point on the eye-level outside the picture at the right. This is known as two-point perspective.

In fig. 114, which represents the observer's relation to the scene as pictured in fig. 112, the direction of sight is at right angles to the ties which are parallel with the picture plane. In fig. 115, which represents the observer's relation to the scene in fig. 113, the ties are not parallel with the picture plane; their left ends are nearer the picture plane and the eye than are their right ends. Hence they converge to the right.

In fig. 112 (and in fig. 114) the observer is exactly in the center of the picture. What happens when, as in fig. 116, he moves over to one side, but not beyond the tracks as in figs. 113 and 115?

In theory his direction of sight remains parallel with the rails and at right angles to the picture plane and to the ties. Now the left ends of the ties actually are *further from the eye* than are the right ends; but both ends are equidistant *from the picture plane* which, in theory, is the determining condition. Therefore, in the drawing, the ties, according to the rules, should be drawn as horizontal lines. Hence there would be but one vanishing point, as in fig. 112.

CHANCE But a drawing made that way would not look as satisfying as it does in the drawing (fig. 117) by Fred Chance, where the observer stands on the track in about the position indicated in fig. 116. From that position it certainly is natural to turn the eye to the left of the vanishing point, particularly since the picture's interest—the horn and whistle—lie in that direction. The camera would practically reproduce what Mr. Chance has done if it were held in the same position taken by the artist as his point of observation. If, however, a third track were to be added (in Mr. Chance's picture) at the right side, the situation would be the same as in fig. 112; then the ties would *have* to be made horizontal. Prove this for yourself by tracing Mr. Chance's picture; sketch the third track at the right and give the ties the same direction as those of the other two. Note the unnatural effect.

113

Drawing by Aldren A. Watson.

114

PICTURE PLANE

115

116

Drawing by Fred Chance.
Courtesy American Locomotive Company.

117

118

119

Just to demonstrate further how Fred Chance's drawing violates the strict rules of scientific perspective, we have laid a rectangle—say a panel of wallboard—upon the track (traced from his picture), see fig. 118. Now place a rectangle of paper on the table before you so that you view it as the tracks are viewed in fig. 116. Can you turn it in such a way that it resembles the rectangle in fig. 118? No, as soon as line A is slanted up from the horizontal (as in fig. 118) line B takes a direction indicated by the dotted line in fig. 118 and by the drawing in fig. 119. Yet if you experiment further by laying a piece of white paper (cut like the rectangle in fig. 118) on the track in Mr. Chance's drawing, it probably will look natural enough.

It would be interesting for the student to experiment further with this subject by making a drawing similar to Mr. Chance's but drawing the ties horizontal. The advantage of the Chance procedure will be quite evident in the comparison of the two effects.

If Mr. Chance had established his vanishing point but slightly to the right, just outside the picture (as in fig. 119) he would have conformed strictly to the "law" of two-point perspective. Then, you see, the rectangle laid on the track would have met the test. But it is obvious that by keeping his vanishing point within the picture he concentrated interest upon the horn and whistle as he could not have done so successfully by following the plan in fig. 119.

The old rule stated, in effect, that we cannot have two-point perspective with one of the vanishing points within the picture's limits. As we shall see, it is a rule that is constantly and effectively violated.

Interestingly enough we have another Fred Chance railroad drawing—the *Fortune* cover (fig. 120)—in which the vanishing point of the track is in almost the identical position as in fig. 117. In this design he *has* followed the rule which says that when a vanishing point falls within the picture, other horizontal lines at right angles to the retreating lines must be horizontal in the drawing. Thus we see that the illustrator uses his judgment in these matters; he is much less governed by perspective rules than by what suits a particular situation.

Cover design by Fred Chance.
Reprinted by special permission of the editors of Fortune.

120

In the painting for an advertisement for the Association of American Railroads (fig. 121) we see a violation of the rule laid down at the beginning of the chapter: the rule that in one-point perspective all horizontal lines should be parallel. We note in this picture that the ties on the tracks at the sides are not parallel; those on the right converge to a point on the eye-level at the right; those at the left seek a vanishing point on the left. In this "one-point" perspective we have three vanishing points, an effect contrary not only to scientific perspective but to what the camera would give us.

Here we should remind ourselves again of the difference between the camera eye and the human eye. The camera, with its lens pointed straight ahead will focus upon every detail within the frame of that picture; it will see each detail clearly. The eye to take in the same scene must change its direction, looking to the left to take in the left part, and to the right to see that clearly. One would even have to turn the head to do it. When we look at the picture of this scene we do the same thing. When we look toward the right it is natural for us to expect the convergence of the ties we see there. Focusing upon them we are but vaguely conscious of the left tracks, even of the center track. It would be interesting for the student to make a drawing of this situation, "correcting" the picture by making all the railroad ties horizontal, then judge for himself which effect looks better. That, after all, should be the determining factor.

FAWCETT

Another very interesting handling of the railroad problem will be found in the drawing by George Giusti and design by Bradbury Thompson on page 63. We encounter this modification of one-point perspective in many situations, notably in the rendering of interiors as demonstrated on pages 56 and 57, where we have experimented with different methods of drawing a kitchen in perspective, borrowing Robert Fawcett's illustration of the woman and stove as our motive.

121

Courtesy Association of American Railroads.

DOOR

CABINET

B

CABINET

CHAIR

A

STOVE 32 in.

EYE LEVEL

CHAIR 18 in.

CABINET 4 ft. 6 in.

122

EYE LEVEL

123

124

EYE LEVEL

125 A

125 B

126

Courtesy Abbott Laboratories,
North Chicago, Illinois.

127

Visitors' Information Center,
Portland, Oregon.

In the interior (fig. 122), we adhere strictly to the rule for one-point perspective, sometimes called parallel perspective because the planes at right angles to the eye (the facing wall and the end of the stove and the front of the cabinet in the drawing) are parallel with the picture plane. In this drawing the eye-level is the same as that of the woman, and the vanishing point is in the center of the room. This is the effect that would be produced by photography when the lens of the camera is viewing the room from the same vantage point.

Now if we move over to the right of the room, rather close to the wall, and direct our camera somewhat toward the door, we get an effect like that in fig. 123. The facing wall is no longer a rectangle; its floor and ceiling lines converge to a point on the horizon far to the left, as do all other lines parallel to them. This is a much more agreeable effect for the simple reason that an arrangement of lines and shapes, as in fig. 125B, is more interesting, less static, than that in fig. 125A. Abbott Laboratories' Brief Summaries (fig. 126) is a good illustration of the superiority of a design layout based upon the perspective procedure of fig. 125B. This is a violation of the old perspective law as is the photograph of the Visitors' Information Center in Portland, Oregon (fig. 127).

There is no reason why, if the effect in fig. 123 is agreeable, we should not keep the observer's position in the center of the room and converge the facing wall lines to a left vanishing point as we have done there. But we have to be careful not to bring the left vanishing point too close to the picture, as has been done in fig. 124, where the drawings of the cabinet and the chair become very distorted. In this kind of problem, as in all others, the illustrator's judgment will rule.

We have to find a way of measuring every piece of furniture in the room; the heights of the stove, the chair, and the cabinet in relation to the figure (see fig. 122). We are assuming here that the housewife is a little over five feet, her eye exactly five feet above the floor. Since the height of the range is the same, we have a five-foot measurement on the wall. Any vertical on that wall between the floor and the eye-level likewise is five feet long—AB for example. Dividing AB into five one-foot parts we can measure on it the height of the chair (18 inches —one and one-half feet). A line on the wall from this point to the VP cuts the corner of the room at X. A horizontal on the facing wall, through X, dictates the height of the chair seat. The cabinet dimensions are 30 inches high to the top of the drawer section; almost six feet from floor to top of cabinet. We carry these measurements around the walls in the same way. We make the door seven feet high.

BOBRI Bobri, the creator of the interesting advertising illustration (fig. 128), is one of our most skillful draftsmen, as well as a highly original designer. In this picture he has taken liberties with perspective which enhance his design without appearing to violate natural effect.

Let us look first at the buildings and the checkered pavement. We might naturally assume that all converging lines of these objects are parallel and therefore seek a common vanishing point at the eye-level; as, indeed, they appear to do at casual glance. But, laying our tracing paper over the drawing and testing these lines, we discover that instead of one vanishing point there are *two,* as shown in fig. 129. They are not very far apart, to be sure, but from the standpoint of design the variation is important. Fig. 130 shows how awkwardly violent the light side of the structure on the right would be if its lines converged to VP¹. The design is better as Bobri has arranged it.

What he has really done is to give that building (fig. 128) the shape of a parallelogram. Side Y in fig. 132 is parallel to the horizontal lines of the pavement, but side X cuts diagonally across them.

Another interesting violation of scientific procedure is seen in the direction of the lines of the battlements of the building on the left (indicated by heavy lines) in fig. 129. These, being parallel to the picture plane, might be expected to be horizontal in the drawing; instead they slant down to the left and all of them are parallel. This might seem to be an accidental minor detail, but to a meticulous designer like Bobri nothing in the picture is accidental.

Now we come to something that is indeed surprising. That is the relation, in size, of the figures. We are at once aware, of course, that the girl's figure is out of scale with other elements in the picture and for an obvious reason; but we are not so conscious—if at all—of the gigantic size of the guard with the halberd in relation to the distant figures and the height of the building itself.

But fig. 131 demonstrates that this personage is about three times the height of the distant figures. Projecting lines forward from VP¹ through the feet and head of one of the distant figures until they reach the plane in which the guard stands—the tinted plane—reveals the proper height for the guard, if Bobri had wished to be photographically correct instead of a designer.

When we see such things done by an expert they seem so simple, as do most things that are right, and it is hard to realize how subtle these adjustments between design and perspective are. It is only when the beginner makes his own attempts that the skill of the experienced designer-draftsman in these matters is appreciated.

GIUSTI George Giusti's drawing (fig. 133) shows the solution of an interesting problem. As shown in *Westvaco Inspirations*, this advertisement spread across two 12 by 9-inch pages. That factor in itself will explain certain "irregularities" in perspective procedure.

First, let us look at the *tonal* section in the upper-right corner. That rectangle isolates what might be called a normal view: it covers about as much terrain as might comfortably be included in a picture of this kind. As a matter of fact it tells the whole story. It is extended beyond its borders only to create an unusual layout and thus further dramatize the *idea.*

128

*An advertisement for
Hanes Hosiery, Inc., by Bobri.*

eye level

vp² vp¹

129

eye level

vp¹

130

STATUE

X

Y

132

vp¹

131

*This is a plan of the buildings and pavement
as Bobri has drawn them.*

Now if a student presented that drawing (the tonal section) in a perspective class, his instructor might point to his error in the rendering of the railroad ties. These, he might say, should be horizontal lines, since the subject is drawn in parallel perspective with the vanishing point nearly in the picture's center. And he could demonstrate the logic of that rule by drawing two diagrams (figs. 134A and B) in which converging lines to the right of the track are made into additional tracks. He could point out that if the direction of the ties of track X (fig. 134A) is correct, those of tracks Y and Z, being parallel with them, must be drawn as shown. But the absurdity of that effect is evident. The device of a third vanishing point for the right track (fig. C) seems equally so. (However, please refer to the painting of locomotives on page 55 where this device has been employed successfully. But in that picture the slant of the ties of the side tracks is so slight that the divergence is scarcely noticeable.) The logical rendering of the two tracks is that seen in 134B. The fact that actually these other tracks do not exist in Giusti's drawing does not justify him *theoretically* for what he has done. But in breaking the rules he has done the most effective thing.

When the converging lines of the ties (within the tonal area) are extended, it will be seen that they meet at a vanishing point far to the left. But, it will be noted, there is no convergence at all of the tie lines outside the tonal area; they are mostly parallel. Indeed some in the foreground diverge slightly. Furthermore, it is the work of two persons. The tonal picture is a drawing by Giusti for a Gruen Watch Company advertisement; the extended tracks and the figures below the picture were added by designer Bradbury Thompson in creating a two-page spread for *Westvaco Inspirations,* for which he is art director and designer. Therefore, what we have here is really not a picture but a design, a design which involves two distinct views, one toward the right-hand page of the spread, the other toward the left page. While the attention focuses upon one page the other is out of focus, hence not really a part of a unified picture, although it is part of a unified design. Although one would expect the perspective inconsistency to be disturbing, it is not because the reader, turning from the train—which is the focal point of the spread—to follow the rails as they come forward on the opposite page, turns the head as he would if he actually were on the spot staring at the rails themselves. Thus there are two separate focal points in a single picture, a feat that demands arbitrary handling of perspective devices.

Another interesting point in this design is the treatment of the figures. Note that while the figures diminish in size perspectively, those in the distance are much larger than they would be if treated realistically in perspective. Converging lines drawn through all the extended hands find a vanishing point considerably above the horizon line. Who cares? The effect is much stronger than otherwise. In this connection, refer again to Bobri's figure treatment in the Hanes advertisement, page 58.

134 A

134 B

134 C

Two-page spread in Westvaco Inspirations *designed by Bradbury Thompson around a Gruen Watch Company advertisement by George Giusti.*

WHAT TIME IS IT? WELL, TO THE MAN OF PRECISION IT IS 8:17, OR 20:17.

TO THE AVERAGE PERSON IT'S ABOUT A QUARTER PAST EIGHT.

TO THE HOBO ON THE PARK BENCH, IT'S JUST DAYTIME OR NIGHT-TIME.

AMERICA'S GREAT PRINTER, BENJAMIN FRANKLIN, ROLLED THE

IMPORTANCE OF TIME INTO A FAMOUS AXIOM, "DOST THOU LOVE LIFE?

THEN DO NOT SQUANDER TIME, FOR THAT IS THE STUFF LIFE IS MADE OF."

TIME CAN BE STRETCHED BY TWO DEVICES. SPEED IS ONE.

PRINTING IS THE OTHER. THE BETTER TRAIN THAT LEAVES AND ARRIVES

ON TIME; THE BETTER WATCH THAT SPLITS TIME INTO

PRECISE SECONDS. HERE, BEFORE YOUR EYES IS A PICTURE MAKING

DYNAMIC DRAMA OF THE OLD SAW, "A MISS IS AS GOOD AS A MILE."

FASTER THAN A COMET THE MESSAGE JUMPS INTO YOUR MIND.

PRINTING DOES THAT TO YOU SCORES OF TIMES A DAY. HE WHO

HAS NO TIME FOR PRINTING MAY SOON HAVE NO TIME FOR ANYTHING.

2 IN THE PRECEDING LAYOUT, ONLY SMALL LETTERS HAVE BEEN USED, WITHOUT TRADITIONAL CAPITALIZATION. THIS USAGE IS GENERALLY REGARDED AS MORE READABLE, BECAUSE OF GREATER VARIATION IN THE SIZE AND SHAPE OF DIFFERENT CHARACTERS, THAN THE USE OF ALL CAPITAL LETTERS AS SHOWN IN THIS LAYOUT. ISN'T THERE AN EVENNESS OF LINE HERE THAT PRESENTS A PLEASANT APPEARANCE BUT THAT MAKES FOR SLOWER READING? ANOTHER PRACTICAL CONSIDERATION IN FAVOR OF EMPLOYING THE SMALL LETTER DESIGNS IS THEIR SIMILARITY TO HANDWRITING, FROM WHICH THEY WERE ORIGINALLY DERIVED.

SPEED TOMORROW'S PEACE: BUY WAR BONDS NOW

3026

A LITTLE TOO LATE...

...IS MUCH TOO LATE

WESTVACO INSPIRATIONS FOR PRINTERS 152

ARTIST: GEORGE GIUSTI
ART DIRECTOR: DAN KEEFE
AGENCY: McCANN-ERICKSON, INC.
ADVERTISER: GRUEN WATCH COMPANY
ENGRAVING: HALFTONE, 110 LINE SCREEN

PRINTED BY LETTERPRESS
ON INSPIRATION SUPER, 25x38-45

PRINTED BY LETTERPRESS
ON PIEDMONT ENAMEL
25x38-70

3027

FAWCETT This dramatic picture by one of America's top illustrators reveals interesting perspective tactics involving four vanishing points. The horizontal lines of the room in which the action takes place converge to VP 1.

Now the casual observer senses that the wall of the further room (gray in our diagram) is parallel with the corresponding left wall of the near room. But when we carry out the converging lines we discover that they seek a vanishing point considerably to the right (VP 2). This means that the further wall is not parallel with the near one; the wall is turned more toward us.

Why should this have been done? The answer is obvious. The effect is more pleasing than if the wall were in more violent perspective, in that case affording less opportunity for the display of its fine paneling, a most interesting background feature. Oddly enough, however, the floor line of that room converges to VP 1, thus strengthening the impression that the far wall is actually parallel with the near one— a very subtle treatment!

The table, we note, is not parallel with the wall of the room as we would expect it to be and as the casual observer suspects; its long sides converge to VP 3. This is a matter of design; imagine how awkward it would be, had that long line converged to VP 1!

We have still another vanishing point; that of the opened door— VP 4.

Until one has analyzed this picture as carefully as the author has done, tracing some of its details, he cannot appreciate the perfection of the drawing of every incidental object. Study the lamp, for example, and the still life objects on the table. Nothing is slighted; each prop is authentic and convincing. And to demonstrate how this illustrator makes even inanimate objects respond to the action that is taking place, note the tilt of the liquor in the near bottle—a minor bit of strategy to be sure, but a master does not overlook the importance of "bit parts."

135

136

Illustration for Collier's *by Robert Fawcett.*

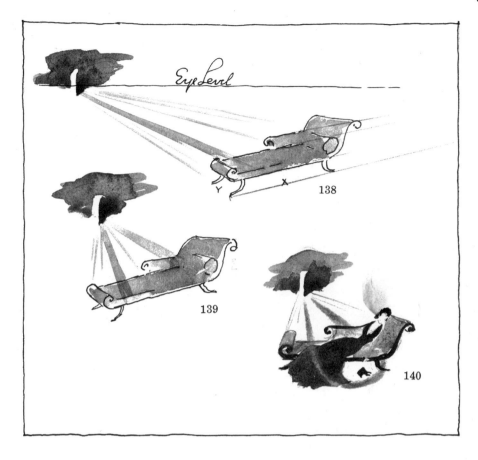

Eye Level

138

139

140

An advertising illustration for Coty, Inc., by John Atherton.

ATHERTON In fig. 138, which is shown above, the chaise longue is drawn as it actually would appear when viewed from the angle which the artist assumed when he established the direction of the long side (X). This can be substantiated by observation of any rectangular piece of furniture. When seen in this position, the short side of the chaise longue (Y) comes into full view.

But had the furniture been drawn in the "correct" manner (as in fig. 138) the design of the picture would have been scattered and ineffective, with the distant door thrown outside the range of interest that should of course be focused on the girl.

Had the same relative position of door and chaise longue (as in Atherton's drawing) been maintained as in fig. 139 and had the chaise longue been drawn "correctly," the design would have been most awkward. In fact, it would have been impossible.

Now suppose that, insisting upon a "correct" drawing of the chaise longue we turn it as shown in fig. 140. In this position—the long side being horizontal—the end lines converge "normally" to the distant door which is their vanishing point. But, as is obvious, the design is static; it lacks the grace of Mr. Atherton's drawing.

Although this is a relatively simple bit of perspective strategy it represents the practiced skill of one who knows how to distort natural appearance in order to achieve unity and elegance of design.

68

EYE
LEVEL

4 BOX0101

IX27 01

1

2

3

4

5

A

VP HORIZON

THE CIRCLE

How infrequently a circular object is viewed from the one direction —"straight on"—in which it appears as a perfect geometric figure that can be drawn with a compass! But of course a circle always *looks* like a circle whatever its relation to the direction of sight; and if the ellipse, which is its perspective appearance, is correctly rendered by the artist it will indeed look like a circle. If, however, its ends are made either too pointed or too rounded it certainly will not look like a circle. Nor will it if it is not perfectly symmetrical.

The student should, at the outset, acquire facility in drawing ellipses. Otherwise his progress in working out problems involving the circle will be greatly hampered. He should do a lot of drawing from models— cardboard circles, plates or other circular forms laid on the floor, the table, and at various other levels.

Try sitting back from the drawing board and swinging in the ellipses with full arm movement. While at first this will be awkward and the first ellipses thus made will fall short of being perfect figures, they are likely to be better than those constructed laboriously by finger movement.

The tracing of ellipses from photographic reproductions in magazines and newspapers will help to develop the correct concept of elliptical figures. Keep up your practice until the drawing of ellipses is really easy and until you are *sure* that you are making true figures.

A practical test of the symmetry of the ellipse is to fold it on its short diameter to see if one side falls exactly over the other, as it should; and to fold it again on the long diameter to test the similarity of the front and back halves. The drawing, of course, has to be on transparent paper for this test; if not, a tracing of it on transparent paper can be made quickly.

Fig. 141 demonstrates some of the perspective facts of the circle when it is associated with the cylinder. At the eye-level (which is also the horizon line) the circular section lines of the tanks appear as straight lines. Above and below this level they appear as ellipses that are progressively "rounder"—to coin an adjective that is useful in discussing proportion—as their distance above and below the eye-level increases. The top ellipses of the tanks are more nearly round than the bottom because their distance from the eye-level is greater.

The proportion of the ellipses—the proportion of short to long diameters—also depends upon the distance of the cylinder from the eye. The nearer the eye, the more nearly round; the further away, the thinner. Seen at a considerable distance they appear as nearly straight lines.

141

The figures give scale to the tanks which are ten times the height of the figures, or sixty feet.
The scene is drawn as though the artist is on some eminence that brings his eye about eighteen feet from the ground —three times the height of the figures. The figures beside the oil truck were drawn first. Their height carried horizontally to A on tank 3 and then projected forward, giving the proper height for the foreground figures.

Another point to be noted here is that the long diameter of the ellipse is at right angles to the axis of the cylinder (shown by white line). We must draw ellipses of all upright cylinders—this means all circles on horizontal planes—upon horizontal long diameters. They always look that way to us, though not always to the camera. A photograph of the tanks would show the ellipses with long diameters slanted down toward a vanishing point at the left on the horizon. The effect would be one of unnatural distortion.

This is one of many differences in camera and human eye vision. It must be said that some distortions of camera vision are not as objectionable to the average person as they were before photography began to accustom the eye to unnatural odd angle effects which fill our picture magazines. Our eyes have been re-educated or conditioned, as it were. Artists have adopted some of these camera distortions and they use them in common practice, as we shall see later. But the rule that the ellipse, representing a circle on a horizontal plane, must be drawn on a horizontal diameter is inviolable; here the camera distortion is not acceptable to the human eye.

What about the ellipses of cylinders seen in the positions other than upright, standing on their circular ends? The drawing in fig. 143, traced from a photograph of rolls of newsprint paper, demonstrates that regardless of the position of the cylinder the long diameter of its ellipse appears at right angles to the cylinder's axis.

The photograph of the grinding wheels (fig. 142) and the diagram (fig. 144)—a tracing from the photograph reduced in size—reveal some interesting additional facts.

First we note that the long diameters of the ellipses are at right angles to the axis lines of cylinders of which they are the circular ends. This relationship of diameter to axis is constant no matter what the position of the cylinder; axis and diameter of ellipse are always at

142 *Courtesy Penninsular Grinding Wheel Company.* 143

144

right angles to one another. When the ellipse to be drawn represents a circle that is not actually part of a cylinder, as the circular face of a rectangular clock (fig. 145), the artist *imagines* the cylinder whose sides and axis line converge with the side lines of the rectangular solid which they parallel.

Always we must remember that the *long diameter of the ellipse is not a structural line of the object:* it is merely an *imaginary* line—useful only for drawing purposes. It is *never* the same as the geometric diameter of the circle which the ellipse represents. We note, for example, that ends of the ellipses' diameters in fig. 144 do not touch the circles where they rest upon the ground or at their uppermost points. And we see that the numerals VI and XII on the clock's face are located on its structural, vertical diameter, having no reference to the ellipse's long diameter which changes direction as the clock is turned one way or another and raised and lowered.

Referring again to fig. 144 we observe that the long axes of the three ellipses are not parallel to each other: that of cylinder 1 deviates from the vertical slightly more than number 3. All three diameters converge upward and, if extended, would meet at a point somewhere in a vertical line, called a *vanishing trace,* through VP[1] which is far off the paper at the left. The vanishing trace is demonstrated in Chapter IX.

In fig. 144 the side lines of cylinder 1 have been projected backward, to the right, toward their vanishing point; and two other ellipses have been drawn within them to indicate how the proportion of ellipses changes (length of long diameter to short) according to distance from each other and from the eye. The photograph of the freight car wheels (fig. 146) illustrates this very clearly. The camera appears to have been quite close to the wheels. A picture taken at a greater distance, though from the same direction, would show less difference in the proportion of the ellipses of the two wheels. Refer to fig. 164 on page 77.

146

145

147

Advertising drawing of
Sydney Harbour, Australia,
for the British Commonwealth
Pacific Airlines, Ltd.

In the drawing of the bridge (fig. 147) we have an interesting application of the principles we have been discussing throughout this chapter. Although the lines of the bridge are not perfect arcs of circles, they are sufficiently related to circles to make the accompanying analysis useful. It shows how essential is our knowledge of the appearance of the circle in all situations where it is even but a part of the object's form. Without such knowledge the artist can make serious errors, even when he has photographs to use; these will not always illustrate his subject in the position in which he is required to view it.

Our analysis (fig. 148A) represents, at least approximately, the relation of the bridge's span to circles which appear to carry the curve of the trusses for some distance. The perspective diagram (fig. 148B) is self-explanatory. We see that the long diameter of the ellipse (dotted line) is at right angles to the axis line of an imagined cylinder and that it lies considerably in front of the circle's actual center (Y), a phenomenon that is discussed presently.

Come back to this subject later when studying reflections. Making a drawing of the bridge with its reflection in the water will be a rewarding exercise.

148 B

148 A

150

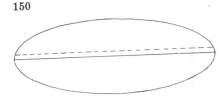

The Observatory on Palomar is another good illustration of the same principles. Here, the ellipses' long diameters slant but slightly from the vertical since the cylinder's axis line, being not far above the eye-level, is nearly horizontal. As in the bridge drawing, only segments of the ellipses become parts of the structure but we need to draw the entire ellipses in order to be accurate with the segments.

Refer to the Peter Helck drawing in later pages for further study of this phenomenon.

Many beginners, especially those who are mechanically minded, are quite surprised to be told that the diameter of a circle and the long diameter of its elliptical appearance are never the same lines; and to discover that the long diameter of the ellipse is always in front of (nearer the spectator) the circle's structural diameter.

Even more convincing than the diagrams here that prove it on paper is a simple experiment with a cardboard circle, preferably a very large one. Hold the model in a horizontal position at arm's length a few inches below eye-level. Better yet, lay it on a shelf about ten inches below eye-level. Now place the point of a pencil on the back rim of the circle and slowly move it forward on the circumference toward the front until it reaches a point that seems to be the extreme right-hand boundary of the circle. Mark this point on the model. Do the same on the other side. Now take the model down and connect the two points with a line. That line, it will be discovered, is not the diameter of the circle: it lies in front of it. Now draw the actual diameter of the circle with a dotted line and put the model back on the shelf. What is seen will resemble fig. 150.

The explanation is simple enough. Though actually shorter than the circle's diameter, the long axis of the ellipse looks longer because it is nearer the eye. The closer the observer is to the circle the more widely separated are the axis of the ellipse and the diameter of the circle. This fact the student should verify by his own experiments.

The photograph of automobiles parked in a circle on Great Bear Lake, on page 76, is an excellent demonstration of this phenomenon.

The Observatory at Palomar, California.

149

AXIS LINE

EYE LEVEL

151

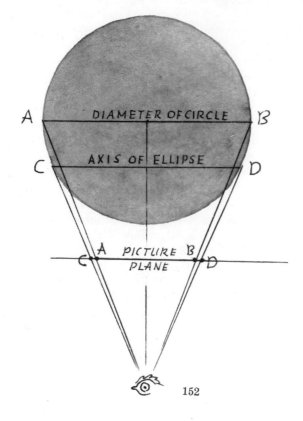

DIAMETER OF CIRCLE

AXIS OF ELLIPSE

PICTURE
PLANE

152

153

154

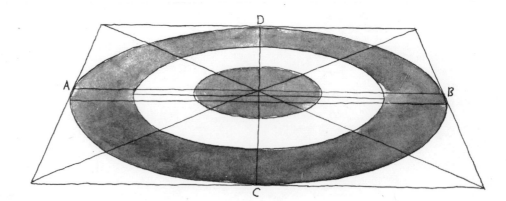

155

After these convincing experiments it seems hardly necessary to demonstrate further the phenomenon by such diagrams as figs. 152 and 153 which represent the spectator viewing the circle from different distances. However, there are other factors to be considered here. In fig. 152 we see that the circle's diameter AB is a shorter line on the picture plane than CD, the diameter of the circle's elliptical appearance from that view point. Fig. 153 demonstrates how increased distance from the circle brings the two diameters closer together. And when the circle is small—as in the clock's face (see page 71)—the ellipse's diameter comes very close to the circle's structural center. In larger objects like the bridge (page 72) the ellipse's long diameter is likely to be considerably in front of the circle's structural center.

Now let us consider the problem of concentric circles which is illustrated in figs. 154 and 155.

Here we have three concentric circles which, in plan, fig. 154, are seen to divide the diameters AB and CD into six equal parts.

After we have drawn the square in perspective and have found its diameters and center, we can divide AB, the horizontal diameter of the square, into six equal parts to give us points through which the ellipses must pass on that line. On the greatly foreshortened diameter CD these points must be so placed as to give a gradual diminution of the six spaces (perspectively equal) between the ellipses from front to back.

The ellipses, as we know, have to be drawn so that their long diameters lie in front of the circle's center. The diameter of the smallest ellipse is so near the center as to practically pass through it.

CHAPIN

A practical application of this phenomenon is seen in the accompanying diagram of the solar system, the orbits of the planets forming a series of concentric circles. That the artist knew his perspective facts can be proved by testing the drawing on an overlay of tracing paper.

156

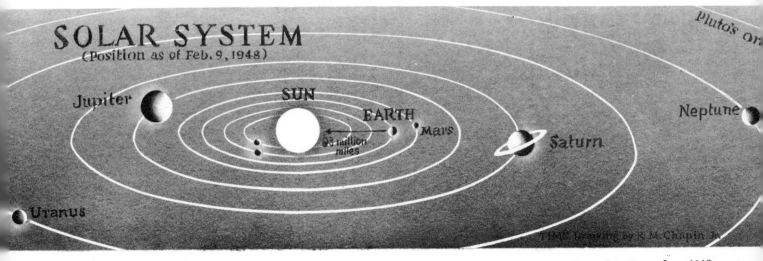

TIME *drawing by R. M. Chapin, Jr.* *Courtesy* TIME. *Copyright* TIME, *Inc., 1948.*

157

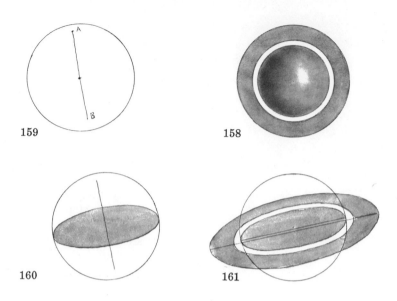

159

158

160

161

The New York *Times* advertisement (fig. 157) presents yet another illustration depicting the globe with the encircling plane which carries the lettering. The top view (158) indicates the relative dimensions of the plane and the globe.

Since we look down upon the globe, the poles (A & B) would not be on its circular contour line; the axis would be foreshortened as in fig. 159, and the center would be slightly below actual center.

In fig. 160 we see the globe encircled at this perspective center. It requires a somewhat cultivated judgment to know whether the ellipse is correct in proportion (long to short axes) considering the position of the globe—below eye-level—which we established when we indicated its poles. In fig. 161 we apply the procedure of fig. 155, consulting the top view for the relative measurements of the various circles.

162 *Ice fishing on Great Bear Lake. Photograph Associated Press.*

Hudson type locomotive of the Chesapeake and Ohio Railroad.

163 A

163

We now come to the consideration of another and most important relationship of the circle and the square. It can conveniently be studied on pages 78 and 79 in the problem of wheels on a railroad track.

Only one of the four ellipses can be correctly proportioned for a wheel seen on that particular track and in that position on the track. (The conditions are identical in all four diagrams.)

When the track is at right angles to our direction of sight; that is, when our direction of sight parallels the ties, the wheels of course appear as perfect geometric circles. On tracks that are viewed at an angle the wheels are seen as ellipses varying in proportion (of short to long diameters) according to the angle the track takes to our direction of sight. On a sharply receding track the ellipses are very thin.

164

165

166

167

168

We are viewing all four tracks at exactly the same angle. The question is, which of the wheels is correctly drawn? The person with a trained and discriminating eye knows that only the ellipse seen in fig. 166 can be correct. He does not need to be convinced by the experiments on these pages which are intended to prove it for the inexperienced student. Even our demonstration will not prove it for the student who has not, through much practice drawing of cubes, learned exactly what a cube looks like in perspective for, as we shall see, the cube helps us here to make decisions.

However, we will assume that the student has in fact acquired a reasonable concept of the cube's appearance in perspective views. He will at once identify fig. 170 as a cube. That means of course that the ellipse drawn on the side (which is the same as that of the wheel in fig. 166) is the correct rendering for a wheel on that track. Fig. 169 is too wide to be a cube and figs. 171 and 172 are too narrow to be cubes.

In order to make this experiment as simple as possible, the track has been drawn so that the rail and the ties cross a horizontal (AB in fig. 173) at the same angle. This means that a cube resting on the rail will present two equal faces; that the diagonal of the top and bottom faces (dotted lines) are horizontal and that the back corners are vertically above the front ones.

Now let us extend the track as in fig. 174. Cube No. 2A occupies the same relative position on the tracks as that in fig. 170; its two vertical faces are equal. The other cubes are placed in such positions on the tracks that the ellipses inscribed within them correspond with the ellipses in figs. 169, 171 and 172. Thus we see that the proportion of the ellipses on the same track depends upon their nearness to the eye.

An interesting application of this principle is seen in the locomotive wheels (page 77) where the small front wheel is very nearly a circle and the furthest driver is a relatively narrow ellipse. The camera man who made the photograph from which this drawing was traced must have been very close to the locomotive.

The diagram in fig. 164 illustrates the logic of this differential in proportion of ellipses. Observers A and B view the two wheels from different distances. The dotted lines represent the central directions of their sight—approximately central between the two wheels. The picture plane for each is, of course, at right angles to the direction of sight. Note that the differential in width, in what would be seen as ellipses, is greater for observer A than for observer B.

On the following pages we make an analysis of a very interesting picture by Peter Helck which demonstrates many of the points covered in this chapter.

169

170

171

172

173

A————————————B

174

1 A

2 A

3 A

4 A

175

*Advertising painting for the New York Central System
by Peter Helck.*

HELCK No living American artist knows more about perspective or uses it more expertly in his work than Helck. The subject here illustrated is simple, compared with many that he is called upon to illustrate. Such industrial scenes as the interiors of steel mills, with their intricate machinery, involve about every kind of perspective problem that can be imagined; busy railroad centers, shipbuilding yards and the myriad activities of business, farm, and commerce put Helck's knowledge and skill to the acid test.

There can be no guesswork in the rendering of such illustrations as the one chosen for this demonstration. As we proceed with our analysis we shall see that every detail of the painting has been constructed with such accuracy as can only result from meticulous observation of scientific method.

Of course Peter Helck did not go through the steps presented in this demonstration; his knowledge of perspective is so thorough and he has employed it so continuously over many years that the procedure here outlined was purely automatic. None the less it was active in his subconscious mind as he made his painting.

The establishment of the eye-level is an important consideration in every illustration; the picture's effectiveness depends in no small measure upon the point of view from which the scene is to be viewed. In order to dramatize the size and power of the large locomotive, Helck established a low eye-level, such a vantage point as might be had by a spectator standing in the ditch below the roadbed. The eye-level is seen to be a little above the foundation slab.

Before discussing problems involved in the circular forms—arches of the bridge and the locomotive wheels—let us take a look at what happens to the straight lines.

Vanishing points 1 and 2, we note, control all the horizontal lines that are parallel either with the length of the bridge or its thickness, also they control the lines of the locomotive on the bridge. But we discover that the horizontal lines of the front of the lower locomotive give us a different vanishing point. That point (VP³) is slightly below the eye-level on the vanishing trace. How is this explained? (For explanation of vanishing trace refer to Chapter IX.)

176

VANISHING **2** POINT

177 A

177 B

178

A heavy paper model of an engine that would be useful to the student in studying this problem.

It is explained by the fact that the locomotive is traveling on a curved track. How do we know this? By the way the locomotive leans as it does when rounding a curve, the inside rail of the curve being lower than the outside rail. If the track were straight, and both rails, therefore, on the horizontal ground plane, we would be able to see the further rail, the roadbed being below our eye-level.

In order to demonstrate the perspective facts of this situation in the clearest manner, let us reduce the problem to its simplest possible terms by resorting to models (page 83) that represent the bridge and the locomotive. We can use a rectangular prism for each, since we are considering only their rectangular aspects. We have drawn the models below the eye because by looking down upon them the points involved can better be demonstrated.

Fig. 179 demonstrates the situation if the track were straight and at right angles to the bridge as shown in fig. 177A. With the track straight, the locomotive would not lean; its upright lines would be vertical.

177B shows the tracks curved as in Mr. Helck's painting. But the locomotive (in our plan) is seen to have the same position as when the track is straight (assuming the center of the circle, of which the curved track is an arc, to be on the axis line of the bridge). Thus its sides are still parallel with the bridge lines that vanish at VP^2 and they would converge to the same point.

On the face of the bridge, in fig. 180 the slant of the leaning locomotive is indicated. The top and bottom lines, we note, seek a new vanishing point (VP^3). This is located on the vanishing trace that passes through VP^1.

In fig. 181 the model of the locomotive has been completed by projecting forward from the rectangle drawn on the side of the bridge. The darkened rectangle under it represents the plan, on the ground, of the model before it was tilted to accommodate itself to the position the locomotive takes on the curved track.

It appears that Helck's locomotive is not centered exactly under the bridge as in our diagram. It is emerging from the arch and therefore it would be at a slight oblique angle to the bridge. But the angle is so slight as to be negligible. Had the locomotive proceeded a full length further, it would have involved a more complicated diagram; turned at a pronounced angle it would have given us two new vanishing points.

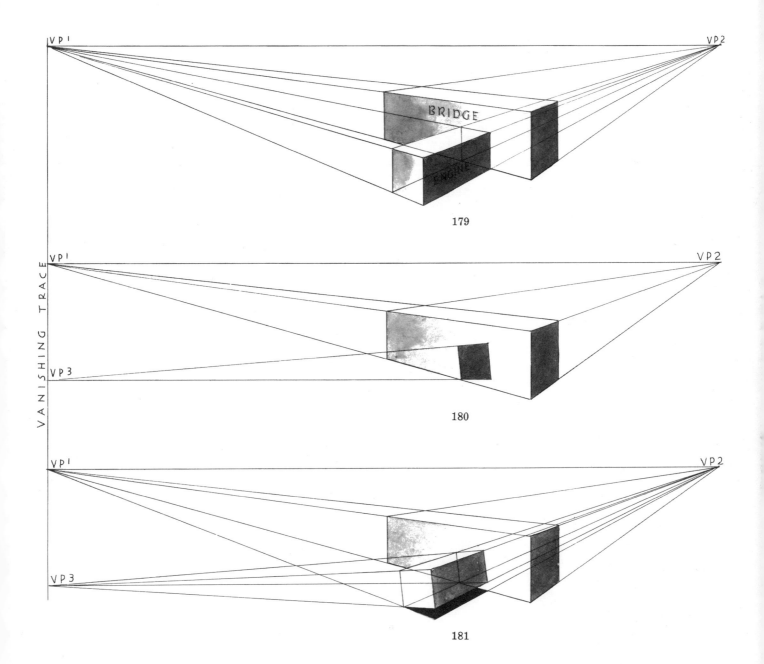

179

180

181

VANISHING TRACE

Let us consider the problems presented by the circular elements of the picture. An analysis of the arches (fig. 182) reveals that they are arcs of perfect circles but are not half-circles; their centers are slightly below the shoulders of the piers from which they spring.

If we visualize the arches as segments of enormous steel collars or pipes, as indicated in fig. 182, it will help to clarify the problem. Think of them as sections cut from long pipes—cylinders whose lines converge to VP².

The axis lines of these cylinders (dotted lines in our diagram) likewise converge to VP² and, drawing the long diameters of the two ellipses (AB and CD) at right angles to them, we discover that they have a pronounced slant from the vertical. Furthermore, long diameter CD slants more than AB because the axis of the near cylinder inclines at a steeper angle than its neighbor.

Now a tracing of the arches in Mr. Helck's picture shows that the further arch was actually constructed according to the procedure just described. But the nearer arch is the arc of an ellipse which has a *vertical* long diameter, as the reader can demonstrate by a tracing laid over the picture. Helck must have deliberately broken the rule here in order to enhance the feeling of the locomotive's speed. Had he constructed that arch on an oblique long diameter, as in our diagram, its backward slanting direction would have opposed the locomotive's forward movement. As it is, there is a sympathetic feeling of forward thrust in this arch. This may seem a very subtle device, as indeed it is.

EYE LEVEL

FURTHER RAIL

183

185

182

Let us next study the locomotive on the ground. In fig. 183, for the sake of simplicity, we have placed the eye-level on the centers of the engine's drivers although in the picture it is slightly below the wheel hubs. If the tracks were straight, instead of curved, and the locomotive, consequently, were in a vertical position as drawn in fig. 183, the long diameters of the ellipses would be vertical as shown, and the further rail could be seen. But the lowering of the rail on the inside of the curve changes this condition; the axis lines of the cylinders (which correspond to the axles of the wheels) slope downward to VP³ just below VP¹. The long diameters of the ellipses, therefore, must take a slanting direction (as shown in fig. 184) in order to be at right angles to the axis lines as they should.

Here again Helck has taken some liberty; he has exaggerated the forward thrust of the ellipses, has slanted them more (fig. 185) than they should be—according to rule—in an effort to force the impression of speed.

The perspective facts of the locomotive on the bridge are quite simple and need no explanation beyond what is shown in fig. 186. The track is straight, of course, and the locomotive is erect as is indicated by the vertical lines of its front. Note, however, that Helck has given the verticals of cab and tender a decided thrust forward in order to enhance the expression of speed. Analysis of the ellipses of the drivers shows that their long diameters are at right angles to the axles of the wheels as they should be. Observe that these diameters are not parallel—the same situation as seen in fig. 182.

184

186

188

189

190

187 *Advertising illustration for
the Axton-Fisher Tobacco Co.
by Albert Dorne.*

DORNE Coming now to Albert Dorne's drawing for the Axton-Fisher Tobacco Company we note that although the problem is a comparatively simple one, its successful solution imposes a thorough mastery of perspective.

In the first place, we have a globe encircled horizontally and vertically (fig. 188). If you lay tracing paper over the drawing it will be seen that the feet of the three legs of the standard—which, of course, are located at the corners of an equilateral triangle (fig. 189)—are on the circumference of a circle of approximately the same diameter as the one that encircles the globe. Thus in fig. 190 we see a cylinder with the sphere just fitting into its top opening, which is the first step in the drawing of the base. The short diameter of the ellipse of the cylinder's base is obviously longer than that of the upper ellipse.

In order to draw correctly the triangle inscribed within the ellipse one just has to know what an equilateral triangle looks like in a given position. To an artist like Dorne this is knowledge acquired years ago before he earned a dollar as an illustrator. And one way to acquire that knowledge is to make one hundred drawings from the model of the triangle within the circle (fig. 24, page 22). Place the model on the floor six feet away; then eight feet away; then ten feet. Set it on a chair and draw it at those different distances. Do the same with the model on a table. It pays to concentrate on this model to this extent because once the correct image is fixed in the mind it is there for keeps.

While on the subject of illustrator Dorne, I suggest turning back to page 15 to study again his drawing for an illustration of a grocery story incident. Note the meticulous way in which he has developed his perspective of every smallest detail; such as the spigot of the barrel in the foreground. See how he has drawn the invisible lines of the object, feeling out its construction with absolute accuracy. It would be quite worthwhile for the student to copy this drawing faithfully, enlarging it considerably. The experience would give him a better appreciation of what it takes to make a master illustrator in this one aspect of perspective skill alone.

191

192

200

193

194

195

196

199

198

197

THE CONE

It will help, in studying the cone, to think of it as enclosed within a cylinder, both figures having the same base and the same axis (fig. 191). There are many situations (as in figs. 192 and 195) in which this cone-cylinder relationship is useful.

Fig. 193 shows the cylinder lying on its side and in fig. 194 the cone's apex has been dropped, allowing the cone to rest upon its sloping side. Note that the long diameter of the ellipse representing the cone's circular base has been drawn at right angles to the cone's axis, a relationship that is constant, as it is with the cylinder.

In fig. 198 we have a form composed of two truncated cones making a spool-like object. Note here the way in which the side lines of the cones become tangent with the bases. The sides of the upper cone become tangent with the top circular base well in front of its diameter; the sides of the bottom cone become tangent with its base behind its diameter. Note also the situation where the cones meet. The sides of the lower cone become tangent behind the circle's center (ends of dotted line); the sides of the upper cone are tangent at points in front of the center (ends of full line). Looking down upon this figure it is apparent that we see more than halfway around the lower cone where it meets the upper one.

The saucepan in fig. 199 has a handle that slopes upward from the rim at a pronounced angle. When the pan is revolved the free end of the handle inscribes an imaginary circle which we can consider the base of a flat cone, as indicated. The apex of this cone is useful in determining the direction of a handle located anywhere on the rim of the pan.

Perhaps it will seem that the demonstration of the perspective structure of Worms Cathedral towers are unduly complicated. "Who," one may ask, "would employ this mechanical procedure in making such a drawing?" The answer is, "No one would." Certainly the author did not do so when he made the pencil sketch reproduced on the next page. But the illustrator who carries such a structural basis in his mind will use it—perhaps unconsciously—as he draws, even when he has the object before him or, as in this instance, when working from a photograph. Learning to draw is considerably more than training the eye to observe accurately and teaching the hand to obey the eye. Many demonstrations in this book are presented not with the expectation that the illustrator will follow the procedures when he is doing professional work, but as training in constructive thinking which certainly he will always employ in whatever he does. On the other hand, there are many, many problems in advertising illustration where the artist will in fact need to make use of intricate engineering strategy even beyond anything covered in this book.

Each cathedral tower has six windows. The hexagon, mechanically drawn in fig. 201, gives points that are projected up to the conical base. These points (A, B, C and D) are the centers of the gable windows and, from them, lines are drawn to the apex of the conical roof. Actually, points C and D should not be located at the ends of the ellipse's diameter as shown in fig. 201. Since they are structural points they should be located at the ends of the *circle's* diameter not the ellipse's diameter. This is shown in fig. 203, in a detail sufficiently enlarged to demonstrate

206

201

202

203 204 205

this phenomenon which is too subtle a point to be considered in the small diagrams; so in figs. 201, 202, 204, and 205 we ignore this perspective fact. However, it is clearly observed in the pencil drawing where the bases of the side gables are obscured by the cone's contour lines.

We erect the side gables at C and D (fig. 201) as high as we want them and connect their ridge lines (FM) by a horizontal line cutting the cone's axis at E. Point E on the cone's axis then becomes the center of two circles that we need for the construction of the two front gables. The larger circle (dotted) establishes the gable's height; a horizontal circular hoop would rest on points F,G,H,M and those on the far side which we cannot see, so will ignore in our drawing. The smaller circle, intersecting lines AX and BX, gives us the points where the short ridge lines meet the conical roof.

In fig. 202 we locate the level of the gables' eaves at point O. Projecting a horizontal line from O into the cone's axis we get point Y, the center of a circle which we need for locating points T, U, Z and Q on the surface of the cone where the short eaves' lines of the gables will go into the cone.

The width of the gables is projected up from the plan in fig. 201.

The points T, U, Z and Q do not actually fall upon radiating lines from apex X, because lines ST and ZU, (fig. 203) are actually parallel lines. However, lines ST and ZU, being parallel lines on a plane that is slightly turned away from the observer, would show at least a slight convergence. But the difference is so slight as to be ignored in drawings. In figs. 204 and 205 are shown sections of the conical tower to illustrate more clearly the structural facts.

209

210

208

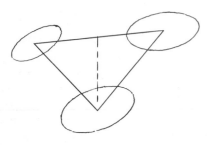

207

RIGGS

It is not likely that Robert Riggs, the illustrator whose drawing is reproduced on the opposite page, constructed a careful diagram like that shown herewith. He is such an expert draftsman that he does not require the mechanical aids needed by the inexperienced artist. No doubt he had recourse to photographs for factual information.

At any rate, we find upon tracing his drawing that its lines, extended, produce the accompanying diagram. Therefore, whatever his procedure, the result checks exactly with our mechanical analysis.

Let us first consider the relationship of the three circles of the listening "ears." Lines connecting their centers form a triangle. But not an equilateral triangle. If it were, we would have an analysis more like that of fig. 208. That is a reasonably true appearance of an equilateral triangle on a plane such as rests against the three ears. We can only conclude that the circles must be constructed on a triangle similar to that of our diagram in fig. 207 and, in perspective, in fig. 208.

It will help the student, in considering the problem, to reproduce this diagram (fig. 207)—much enlarged—on a piece of stiff cardboard and hold it in a position that approximates the plane of the circles in the picture. He should make the sides of the triangle ten inches or so, and ink the circles to make them suggest those of the drawing. He will discover that the circles on the cardboard do not look quite as they do in the Riggs drawing. The long diameters of all three ellipses on his model will be parallel, whereas in our fig. 208 they are seen to take different directions. This is because in the object—hence in the drawing—the circular bases of the cones do not lie in the same plane; they all tilt away from the triangular plane ABC due to the fact that the axes lines of the cones converge to a point instead of being parallel. Having discovered that the axes lines of the conical listening ears meet

211

at a common point, and that their bases form a triangle, we have the triangular pyramid ABCD as seen in fig. 209.

The apexes of the truncated cones are located somewhere between D and the triangular base ABC. These points (E, G, and H) are found by extending the lines of the cones (as we have done in our tracing) until they meet the axes lines AD, BD, and CD. Since the axes of the three cones are the same length, a triangular plane connecting them (E, G, and H) will be parallel to the triangular plane ABC.

Similarly, another triangular plane, parallel with the others, is formed at K, N, and M; points that indicate the centers of the small ends of the truncated cones.

We have already noted that the three circular bases of the cones do not lie in the same flat plane. The cone A being tipped toward us more is represented by a base that is somewhat "rounder" than B which is turned upward and away. The base of cone C being turned away from us even more than B is a very narrow ellipse.

Furthermore, in our diagram (fig. 210), we observe a perspective variation in the lengths of the truncated cones and their axes lines AK, BN and CM, due to the different degrees of their foreshortening; the nearest one (AK) being the shortest because it is turned away from us at the sharpest angle.

Finally, consider the long diameters of the three ellipses (fig. 210). Each is seen to be actually at right angles to the *axis* of the cone as is always the case regardless of the cone's position.

This analysis may seem quite complicated to the novice but to one who has acquired enough skill to draw the object at all, the procedure outlined is very simple. Most artists might use such a diagram as a check on the correctness of a freely drawn illustration, rather than as a preliminary framework upon which the final rendering would be carried out.

to V.P 3

to V.P 6

to V.P 6

to V.P 4

to V.P 6

to V.P 4

to V.P 4

to V.P 4

to V.P 2

to V.P 1

to V.P 7

to V.P 1

to V.P 1

The House of Seven Vanishing Points

to V.P 1

HORIZON LINE

to V.P 5

214

to V.P 5

VP 4 VP 2 VANISHING TRACE VP 7

215

THE HOUSE OF SEVEN VANISHING POINTS

The House of Seven Vanishing Points may look confusing to the beginner, but when studied step-by-step on the following pages it should present no difficulties.

The student is advised to make an instrumental drawing of this subject, perhaps half again as large as fig. 214, carrying out all of the converging lines to their vanishing points. Since some of these will fall at too great a distance to be located on the drawing, additional sheets of paper will have to be cellophane-taped to the drawing to extend the field of operations. When drawing instrumentally one should use hard leads that are kept well-sharpened to a fine point.

The main structure, of course, is as simple as fig. 212, a rectangular solid topped by a triangular prism. The peak of the gable is on a vertical line passing through the crossing of the diagonals of the rectangular end.

The vanishing points of all converging lines other than the horizontals that converge to VP[1] and VP[2] will be found in the vertical *vanishing trace* which passes through VP[1]. The logic of the vanishing trace is demonstrated in figs. 213 and 215. Fig. 213, it will be seen, is fig. 212 turned so that the building stands on end. The horizon line of fig. 212 becomes the central direction of sight in fig. 213 and the vanishing trace becomes the horizon line.

In fig. 215 we have laid the house on its side to show how logically the roof lines of the dormers, which are in the same plane as the building's side, converge to the vanishing trace established by the perspective of that plane. This figure had to be drawn here in violent perspective in order to get the vanishing points on the paper. It will be seen that the dormer roof lines of the large house converge very slightly. That is because they are on a plane (the side of the house) which, being turned but slightly away from the observer's direction of sight, has its vanishing points at great distance from the building.

212

213

217

216

The next step is to measure off the widths of the dormers on the eaves line (AB in fig. 217). To do this we have recourse to the simple geometric device illustrated in fig. 216, where we wish to divide the line AB into any number of equal parts—five for example. First we draw AC, a line of indefinite length, at any convenient angle to AB. On this we measure off five equal dimensions of any length from A. These dimensions could have been larger or smaller, though it is best not to have them too large. From C, a line is drawn to B, and lines parallel to CB are drawn from the four other points on AC to AB.

Fig. 217 shows how we apply this device in perspective. The procedure is different in some particulars though the principle is the same.

Instead of making the AC line of *indefinite* length, we establish its length by a line from VP¹ through point B. This makes AC perspectively equal to AB. On AC we now measure off the dormer widths and the spaces between them. Since line AC is parallel with the picture plane—hence is not foreshortened—we can use ruler or dividers to lay out our measurements on it.

Lines drawn from the dormers, indicated on AC, to VP¹ are parallel *in perspective* to line BC; hence they translate our measurements with perspective accuracy to line AB.

When the angle between the AB and AC lines is as acute as in fig. 217, the converging lines that mark off the divisions on AB cross it as such acute angles as to make accuracy more difficult than if the BAC angle were wider.

If, instead of laying out our measurements on line AC in fig. 217, we extend the building downward, imagining its base line to be DE, we have a wider angle and the measuring lines that go to VP¹ cross DE at a better angle (more nearly at right angles) for accuracy. The points on DE can then be projected up to the eaves line. This is a very useful device for measuring perspective distances on foreshortened surfaces; the need for it is frequently encountered. If we wished to

locate doors and windows on our building, for example, we would do it this way rather than working from the eaves line.

Now for the drawing of the dormers. By showing three dormers, in fig. 218, in three stages of development, we can demonstrate each step to be taken. In A we indicate the side lines on the roof that, being parallel with gable line X, converge with it to VP³ (see large drawing).

Next we must find the ridge lines of the gables. We see, in dormer B, the vertical center line OP and a line drawn from O up the roof to VP³. Where this line is intersected by the ridge line (which is parallel with line Y, hence converges with it to VP¹) we have point S where the ridge meets the roof.

We need but one other point, point N, at C. It is found by extending the dormer's eaves line from M toward VP¹. (The dormer's eaves as well as their ridge lines are parallel with line Y.)

If all these operations are carried out accurately, we shall find by testing the drawing that we have the various sets of converging lines shown on our large drawing. The roof lines of the dormers (fig. 219) converge to VP⁴ and VP⁷ as shown on the diagram in fig. 215. The lines that converge to VP⁶—they are on the same plane as the roof—come to a point rather close to the roof because the roof plane slopes sharply away from the observer. These lines are not parallel with the gable line X of the roof, so they do not converge to a point on the vanishing trace.

If the dormers are correctly constructed as described, one does not need to worry about the convergence of the gable lines that point to VP⁴ and VP⁷ or about those that converge to VP⁶. It is quite unlikely that an illustrator would carry these lines out to their vanishing points.

Note in fig. 219 that all the S-points are on a horizontal line that converges to VP²; likewise the N-points, the M-points and the P-points. Knowing this, we do not have to go through all the structural operations here described for every dormer; having constructed one, the others can be largely constructed by projecting these structural points of the first as we have done in figs. 218 and 219.

The chimney is the one remaining detail to be considered. In fig. 220 two stages in its drawing are shown. At A we indicate the joining lines of the chimney on the visible roof. At B we see lines drawn from points D and H down the invisible sloping roof toward VP⁵, since they are parallel with line X which converges to that vanishing point. From points O and P, lines are directed toward VP¹. These lines are horizontal and parallel with line Y which also points to VP¹. We now have the opening through which the chimney will project.

For the sake of greater clarity of demonstration, at B we have projected upward the section of the building—imagining it to be solid—that we have cut out to admit the chimney.

In this, as in all other perspective problems, the "X-ray vision" which sees through the object and develops every point of construction is absolutely essential. We have to feel around and through the object, thinking of it as a three-dimensional object rather than as a flat drawing of it on paper. In this problem we must imagine ourselves *on* that building, laying off the lines for the cut in the roof on the near and visible slope, then going over the ridge and doing the same on the other side. That kind of imagination develops our structural sense.

218

219

220

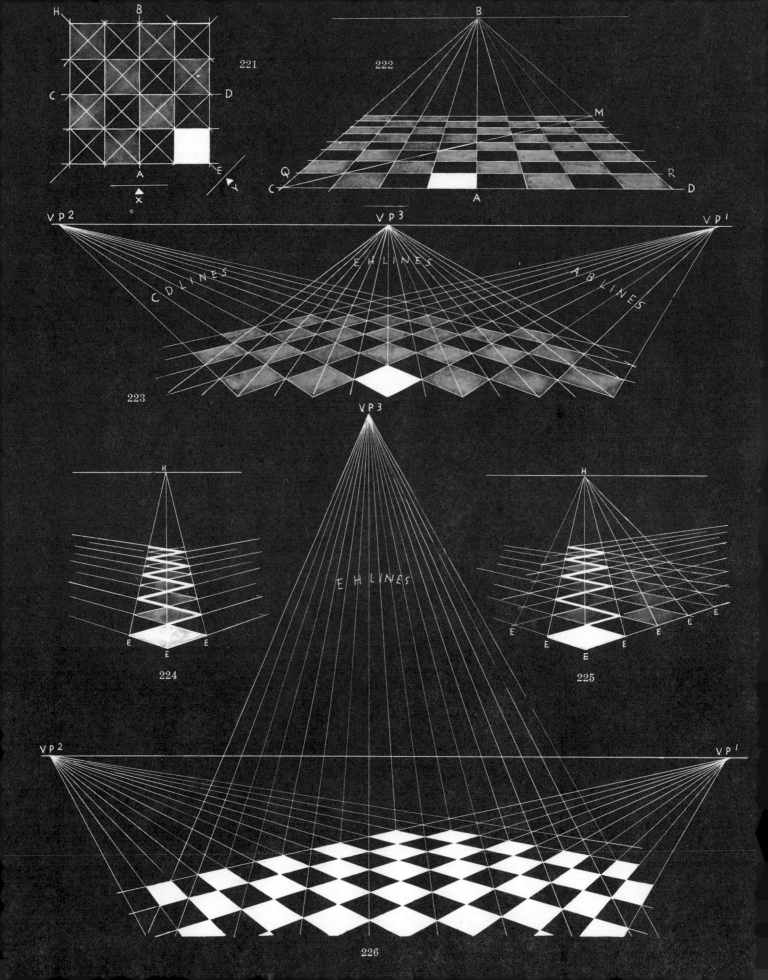

221

222

223 — C D LINES, E H LINES, A B LINES, VP 2, VP 3, VP 1

224, 225

226 — VP 2, VP 1, E H LINES, VP 3

chapter x

FLOOR TILES

Before making the perspective drawings on page 98, it is advisable to consider the diagram in fig. 221 which presents a framework composed of four sets of lines. The vertical lines we will call AB lines; the horizontal ones CD lines. Whether we wish to draw the squares in one-point perspective as in fig. 222 or in two-point perspective as in fig. 223, we use the same framework. In the first instance we view it from position X; in the second our line of sight is from Y.

In fig. 222, after laying out the width of the squares with ruler or dividers on the nearest CD line, we draw the AB lines converging to a vanishing point on the eye-level.

There is no mechanical method (in freehand perspective) of determining the placing of QR—the line that will measure off the front-to-back dimensions of all the foreshortened squares; we have to rely upon our acquired knowledge of the appearance of squares seen at various levels. So, using our freehand judgment, we draw one square (white) which determines the position of line QR and the layout of the entire framework. The diagonal CM which is an extension of the diagonal of the extreme left square establishes points for all CD lines where it crosses the AB lines, as in the diagram (fig. 221).

When we wish to lay the pattern as seen in fig. 223 (viewed in fig. 221 from Y) we draw our first square freehand and find its right and left vanishing points on the eye-level. Then the EH lines are drawn to serve as guides for the procedure in fig. 224; we first draw the dark zig-zag lines, converging to their vanishing points; then the light zig-zag lines. We now have the row of squares immediately behind our first white one. We see in fig. 225 how the pattern is completed by the drawing of all EH lines (see fig. 221) which pass through the intersections of converging AB and CD lines and meet at a vanishing point on the eye-level. This may sound confusing in the reading but when drawing, all will be clear.

Now the drawing in fig. 223, although produced in "correct" scientific perspective, gives a distorted pattern. The squares at the sides certainly do not look like squares; they are elongated rectangles and their distortion increases with the distance from the center square.

Fig. 226 shows how this difficulty can be largely overcome merely by raising the vanishing point for the EH lines considerably above the eye-level. This is what the illustrator of the Coolerator picture (fig. 233) did with his floor pattern. Just how high that vanishing point should be in any given situation is a matter for experimentation. The student would do well to try lower and higher points.

This device is not perfect; it gives us some distortion at the sides where the squares begin to look too long from front to back instead of from side to side as in fig. 223. And they get too long from front to back in the near foreground. But certainly the effect is much improved.

*Interior of a Dutch house by Pieter de Hooch
(Dutch, 1629-c.1683). National Gallery, London.
If you will put tracing paper over the
painting by Pieter de Hooch and carry out all
converging lines, you will find that the
painter was meticulous in laying out
his perspective scientifically. But do his
square tiles look square? Are they not
somewhat too narrow from front to back?
Experiment by laying a few squares of paper
on the floor of your room. Then develop on
your tracing the "corrected" tile pattern.*

*Courtesy Maurice Weir.
In this photograph note the slight
distortion of the squares at
sides of the picture — evidence that
the camera does not see things as
does the human eye. Refer to the
second paragraph on page 10.*

228

229

233

Coolerator freezer advertisement.
Courtesy Coolerator Company.

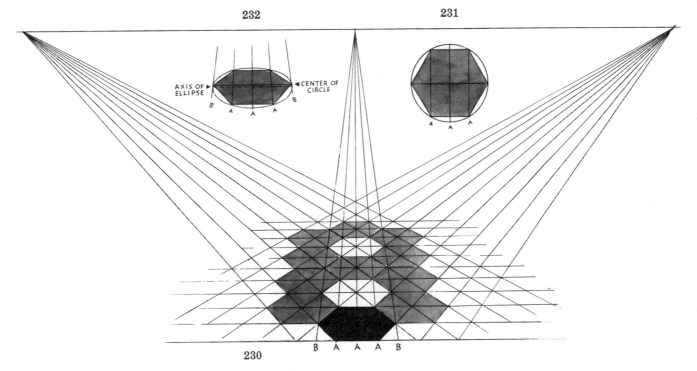

232 231

AXIS OF ELLIPSE ▶ ◀ CENTER OF CIRCLE

B A A A B

A A A

B A A B

230

The hexagon pattern, fig. 230, is no more difficult than that of squares. In fig. 231 we note how a hexagon can readily be constructed within a circle by dividing the circle's diameter into four equal parts and drawing parallel lines A, A, A vertically through the division points.

Fig. 232 is the same operation in perspective. We divide the circle's diameter into four equal parts and, after drawing the center A line vertically and extending it upward to an estimated eye-level, project the other A lines and B lines to the same point as seen in fig. 230. The placing of the eye-level has to be judged according to the proportion of the ellipse we start with; the longer the vertical axis, the higher the eye-level. When the eye-level is already known, as is the case when we are laying a hexagonal floor in a room interior, it is the proportion of the ellipse that has to be judged in relation to its distance below the eye-level. This can be accurately done only after a lot of practice drawing of circles at various levels.

After the first hexagon has been drawn and the A and B lines carried out to their vanishing point on the eye-level, the pattern develops itself, the diagonal lines to their vanishing points crossing in such a way as to give all needed lines and points to complete the pattern.

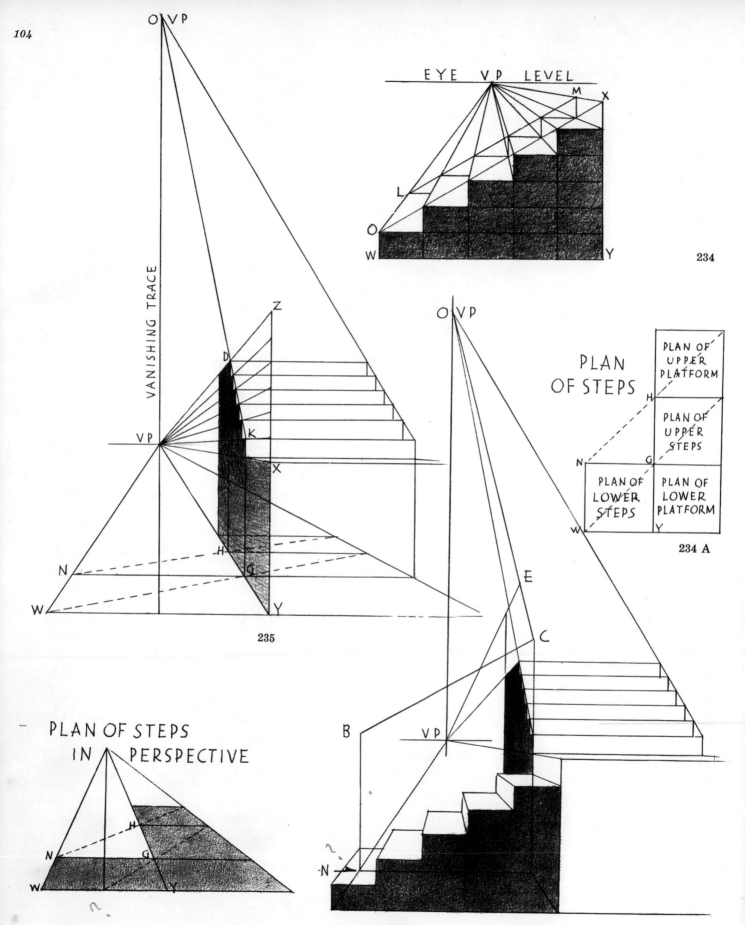

O VP

EYE VP LEVEL

M
X
L
O
W
Y

234

VANISHING TRACE

O VP

Z
D
K
X
VP
N
H
G
W
Y

235

PLAN
OF STEPS

PLAN OF
UPPER
PLATFORM
H
PLAN OF
UPPER
STEPS
N
G
PLAN OF
LOWER
STEPS
PLAN OF
LOWER
PLATFORM
W
Y

234 A

O VP

E
C
B
VP
N

PLAN OF STEPS
IN PERSPECTIVE

H
N
G
W

236

chapter xi

UP STAIRS AND DOWN

Our problem here is the drawing of two flights of steps (fig. 236) in one-point perspective. Consult the plan as we proceed. We begin with the lower flight (fig. 234).

The height of the rise XY we shall assume to be three feet. We would have to determine how many steps of suitable dimensions are needed. If we decide upon a 6-inch riser, we shall need six risers and five treads. With a 6-inch riser an 11-inch tread is desirable.

First we draw line WY, which should be 55 inches long. The vertical line XY, which is 36 inches high, will serve as a scale in making this measurement. After dividing line WY into five equal parts (11-inch divisions) we project lines upward. Lines projected forward (left) from the 6-inch divisions of the line XY give the measurements for the risers. The line OX passes through the projecting corners of the steps. The line LM, drawn parallel with it, intersects the converging lines of the steps and terminates them at their far ends. That is all there is to it.

To draw the upper flight of steps (fig. 235) we will do well to make a plan as we have done at fig. 234A. Then we can draw the same plan in perspective (fig. 235) starting with that of the lower steps which is a square. Having drawn that and the plan of the lower platform adjacent to it, which is also a square, we can readily lay-out the remaining two squares geometrically as suggested by the dotted lines.

Since the upper flight is to duplicate the lower, we can extend XY upward and from X step off on it six riser heights equal to those of fig. 234, giving us point Z. From point Z and from the five other measurements we draw lines to the vanishing point.

What we want now are points K, the corner of the first step, and D, the corner of the top step at the platform level. These points are found by projecting points G and H up from the plan as illustrated. A line from K through D to OVP (point opposite VP) gives us points for the other steps as it cuts the horizontals from ZX to VP. The rest is obvious.

In fig. 236 we have drawn a rail which should be 30 inches higher than the treads of the steps. We can take our measurements from the 6-inch riser on the line NB. Point B is 36 inches from the ground and 30 inches above the tread. The rail BC can then be drawn parallel with the rise of the stairs. Point E is easily established by a line from C to the vanishing point OVP already established in fig. 235.

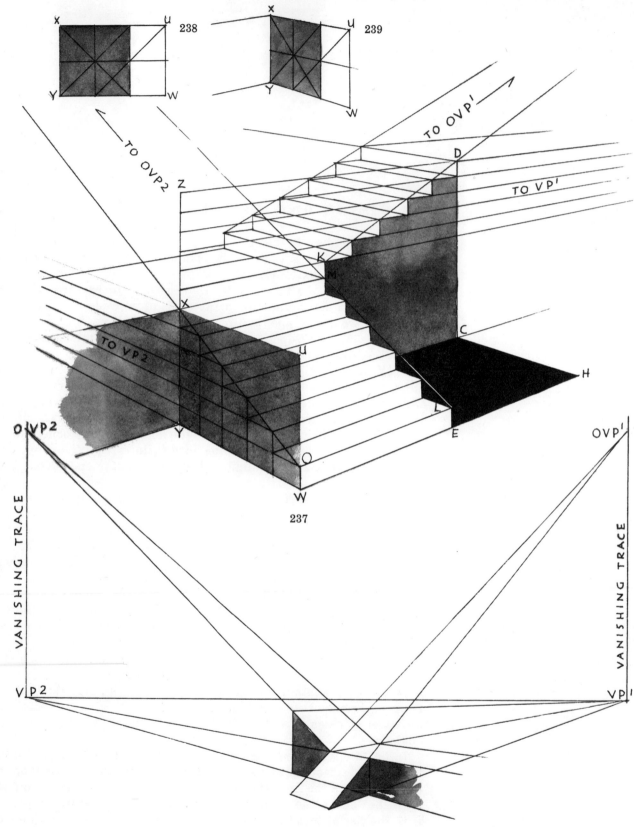

238

239

TO OVP¹

TO OVP2

Z

TO VP¹

D

X

K

M

TO VP 2

C

U

H

Y

L

E

O

OVP¹

OVP2

W

237

VANISHING TRACE

VANISHING TRACE

VP2

VP¹

240

When the same stairs are viewed from an angle, as in fig. 237, the procedure is the same, except that we cannot put a ruler on the line WY as we did in fig. 234 to measure the widths of the treads. What we have to do is to draw a rectangle XYUW (shaded) that is 36 by 55 inches. In figs. 238 and 239 there is a suggestion for doing this. First draw a square in perspective against the vertical XY. By the use of its diagonals, as in fig. 239, we get a 36 by 54-inch rectangle (a square and a half) in perspective—close enough to 36 by 55 inches. When we have done this, we mark off—by estimation—five equal spaces (perspectively) on WY.

Note that the actually parallel lines OX and LM, being on a receding plane, converge; as do the corresponding lines on the upper flight. In fig. 240 we see these lines meeting at points directly above the right and left vanishing points on the vanishing traces. Since the angle of rise from the horizontal is the same in both flights of steps, both points are the same distance above the two vanishing points.

OVP

VANISHING TRACE

TO ALL TRAINS

VP

O A
Y X Z
B
C

242

Drawing by David Hendrickson for
The Travelers Insurance Co.,
Hartford, Connecticut.

There is really nothing new in the interior of the railroad station (fig. 241). Note how the figures are scaled to the steps, which are assumed to have 6-inch risers. The lower flight has eleven risers, giving the first platform a height of 66 inches. The figures have been made about that height, which has been projected up to follow the line of traffic along the platforms and up the other steps.

The heights of the risers of the upper flight have been laid out on the ABC line and projected back to the center vanishing point. The vertical measurements of all steps are thus laid out on the one facing plane (TO ALL TRAINS) upon which there is no foreshortening to complicate things. After points X and O have been found—by lines from Z and A to VP cutting the verticals of the archway on the right—we draw a line from X through O extending it upward until it intersects the vanishing trace at OVP. From OVP to point Y we then have a line that establishes points for the step corners at the left.

HENDRICKSON An analysis of David Hendrickson's drawing for the Travelers Insurance Company represents some interesting points.

First note that the artist has used two vanishing points although one of them is within the confines of the drawing. This "violation" of the "rule book" improves the design of the picture by giving a slanting direction to that top step instead of a horizontal one. Refer to Chapter VI for a discussion of this point.

Note that the lines of the upper stairs converge to the vanishing point with those of the lower flight. Of course they are parallel lines.

243

HILL

V P1

RIVER

V P2

V P3

V P4

chapter xii

UP HILL AND DOWN

Do you have trouble getting up or down hill with your pencil? Does the inclined street refuse to incline in spite of your graphic struggles? Does perspective, which you profess to understand, somehow fail to work in hilly country? If so, you are one of a large company.

The fact is that students who get along nicely on the level encounter difficulty when the road descends before them or climbs up the side of yonder hill. They appear to know their perspective, yet when the sketch has been completed according to the rules, the street looks as level as a floor.

The perspective rules are simple enough, but they seem inadequate. One soon discovers that the illusion of up and down is not secured merely by correct perspective method. Science alone will not always do the trick. Art, or rather artifice, must be combined with science; strategy must accompany mechanical skill.

244

For example, in the down street, illustrated, an auto van parked at the curb becomes an important element in the illusion, because it conforms to the inclined plane upon which it rests instead of being adjusted to it as are the houses. The van thus presents several points of difference: its top cannot be seen as can the horizontal roofs of houses below the eye-level; its uprights tip forward in contrast to the verticals of the houses; its converging side lines follow the curb lines *down*, instead of going with the roof lines to the eye-level.

245

Again, emphasis is given to the horizontal lines below eye-level and to the tops of objects which the spectator looks down upon. Accenting the sill lines of the buildings calls attention to that telltale angle with the sloping street and creates a *step-down* impression which is important.

The *step-down* effect is in fact nearly indispensable. When lines which the observer knows are horizontal are shown at an angle with the street, the illusion of an incline is assured. The greater the angle, the more pronounced the sensation of incline. For this reason a steep hill is more easily depicted than one with a gentler slope which demands those subtle artifices suggested above.

The Yonkers Street (figs. 244 and 245) is especially interesting because it involves four vanishing points. All horizontal, parallel building lines converge to VP1 on the eye level. The street lines converge downward to VP3 directly underneath. But, it will be noted, the angle of the street's principal incline changes at a point near the hydrant; from that point to the foreground it is less inclined. Hence we have another vanishing point (VP2).

Where the further truck is parked, the street obviously dips down at an even greater incline; it is so steep that it cannot be seen. But the top and bottom lines of the truck, converging downward, give still another vanishing point (VP4).

246 247 248

Figures 246, 247 and 248 suggest an experiment for demonstrating the few perspective facts involved. A piece of cardboard with pencil lines to suggest the curbs will represent the street. Cardboard boxes or wood blocks will serve as models for houses when doors and windows have been indicated.

When the street is horizontal as in fig. 246, of course its lines converge with those of the buildings. But when it is tilted as in fig. 247, its converging lines meet at a point directly below the eye-level vanishing point. This new vanishing point is directly below the eye-level on the vanishing trace.

The important fact to remember is that the tipping of the street plane does not affect the perspective of the buildings: an obvious enough truth, yet a frequent point of confusion for the beginner.

The inclined street (fig. 247) cuts across the doors and windows. In order to reproduce the true effect of a street, the house models should be adjusted in height to conform to the grade of the street as shown in fig. 248. Notice the step effect produced by the sill lines in fig. 248.

In the up-hill sketch—a steep street in Assisi, Italy (fig. 249)—the inclined street lines naturally converge upward and the horizontal building lines seek a point directly below. The spectator's eye is about on a level with the curved tops of the doors of the building on the left.

249

"A Street in Assisi, Italy."
Pencil sketch by the author.

250

114

New York University Law Center, Eggers and Higgins, Architects.
251

252
Oil painting by Walter Klett.

chapter xiii

THREE-POINT PERSPECTIVE

Perspective books written a generation ago were not concerned with problems discussed in this chapter. Until comparatively recent times no one ever thought of rendering a vertical line other than vertical. Until the advent of skyscrapers, people actually didn't have to tip back their heads to take in the roofs of such structures as were common up to fifty or sixty years ago. To be sure, there were the great temples of Greece and Rome, and towering cathedrals such as Rheims and Cologne to make tourists crane their necks in viewing lofty cornices and majestic spires.

But until the camera taught people that vertical as well as horizontal lines converge when viewed from below or above, that phenomenon was ignored by artists. We see no evidence of it in the old prints which recorded artists' impressions of those far away days. And although the early photographers discovered that their lens when pointed upward produced converging uprights, they were careful to handle their cameras so as to avoid the then unfamiliar effect.

As buildings reached upward to the sky, however, it became no longer possible to overlook the importance of vertical convergence which now is the concern of every photographer and illustrator. And when the airplane provided man with wings, his familiar world, now seen from on high, assumed new aspects that the illustrator had to reckon with. Viewed from above, vertical lines were no longer vertical; the old reliable horizon line began to tilt and slant in alarming fashion. To cope with this situation the old rules had to be revised and amended.

The camera and the cinema have long ago accustomed people to the effects which at first seemed distortions. Close-ups taken with tilted cameras opened up new and dramatic possibilties in picture-making. The camera has made objects actually look different to us than they did formerly.

These new facts of appearance do not involve new rules; the old principles have only to be adapted to the new conditions.

KLETT The value of vertical foreshortening is convincingly demonstrated by a comparison of the two pictures shown on the opposite page. The first picture is an architect's typical rendering of a building designed by his firm. Fig. 252 is a reproduction of a painting by illustrator Walter Klett. Both buildings are viewed from approximately the same height and the same angle. In the former, all vertical lines have been drawn exactly vertical; in the latter they converge downward and, if projected, would meet at a point far below the picture. Note that the Law Center actually seems to be broader at the foundation than at the eaves; its upright lines appear to converge to a point above. It is an unnatural effect.

253

*Illustration by Al Parker for
a story in* Good Housekeeping.

254

Now when we look down upon buildings from the air we adjust our picture plane—that imaginary transparent plane—so that instead of being a vertical plane it is at right angles to our downward direction of sight. Not only will all vertical lines now appear to converge downward; the heights of the windows will diminish in the lower stories. Observe this in Carl Bobertz's street scene on page 117.

We have become so habituated to the appearance of downward convergence of verticals that three-point perspective is commonly used even in the rendering of furniture and other low-lying objects. Close-up camera shots from above will give this kind of effect to any object.

255 *Drawing by the author of office desk and chair.*

*An illustration by
Carl Bobertz for a
story in* Collier's.

PARKER Yet, turning to Al Parker's picture *The Amateur,* on page 116, we note that this famous illustrator ignored downward convergence in this instance. Although all the upright lines of the building slant from the vertical to give the downward-looking impressions, they are parallel. It would be interesting for the student to experiment with this picture in an effort to discover why the artist did not converge those verticals downward. Leave the corner of the house as it is but converge the lines of the window and blinds. Would the design be less pleasing?

MARINSKY Now let us analyze Harry Marinsky's painting for Shell Oil Company, on page 119, and see what kind of perspective layout it is based on. Fig. 258, page 119, is a reproduction, greatly reduced in size, from a mechanical analysis traced from the author's picture. Ignore the dotted lines and point X in this diagram for the present; we will refer to them a little further on.

The first step in making such an analysis is to carry out the converging lines of the roof-tops to their respective vanishing points (A and B). A line connecting these points is, of course, the horizon line on the level of the observer's eye.

Then extend the building's vertical lines until they meet at a point below the picture. Next draw a vertical line from point C to the horizon line—a line *at right angles to the horizon.* This line, which is the center line of vision, will be seen to pass through the vertical building lines that are actually vertical in the picture; that is, at right angles to the horizontal bottom line of the picture.

Now the horizon line in Mr. Marinsky's picture is horizontal as it would be if the spectator were looking down upon the scene from a very high tower; or if from an airplane, the plane were flying on an even keel, that is, with its wings parallel to the earth's surface.

What if the airplane were to bank as it does when flying in the arc of a circle instead of in a straight line? In that case the horizon line—in a photograph taken from the banked plane—would be tilted at an angle to the actual horizon.

Suppose Mr. Marinsky had chosen to give the effect of a view from a banked plane—all he would have had to do, having first laid out his perspective as described, would be to cut a mat and lay it over his picture as indicated by the dotted line in fig. 260.

SIEBEL In most instances the illustrator would follow the plan employed by Marinsky—a horizontal horizon, but there are times when it is effective to use the tilted horizon. Such is the very dramatic picture that Fred Siebel painted as an advertisement for the John Hancock Mutual Life Insurance Company. In studying the analysis of this picture on page 121, it will be seen that it was first laid out with a horizontal horizon. Siebel achieved a tilted camera effect merely by the way he has masked his picture. Cut a rectangle the size of the photograph in the center of a sheet of paper and lay it over the diagram of the secretary (fig. 262) with the vertical sides of the mask parallel with the center line of vision. Your mask will coincide with the dotted line in fig. 262. Then you will see how the drawing was laid out in the first place: the vertical sides of the picture at right angles to the horizon line, the horizontal sides parallel with it. The center line of vision, it will be seen, runs through the secretary a little to the left of its right side and, of course, is at right angles to the horizon line. Now turn your mask and you will see how the effect of the picture was achieved.

257

258

HORIZON LINE

POE

A

B

CENTRAL LINE
OF VISION

X

C

260

Of course there is violent distortion in Siebel's drawing. All three vanishing points are too close to the object to give a strictly natural appearance. Angles X and Y are sharper even than right angles. The study of similar situations in your own home will convince you that such angles are impossible; the X and Y angles would have to be wider than right angles instead of narrower. However, no one would think of criticizing the drawing, because the distortions are managed in such a masterly way as to give a dramatic and satisfying design.

I think it wise at this point to call attention to erroneous instruction, sometimes given, in locating the C-point in a three-point perspective drawing. This is the notion that the ACB angle should invariably be a right angle. (See fig. 262A.)

The fallacy of this notion is easily proved by making analytical studies of drawings and photographs as we have done with Marinsky's painting. If Marinsky had obeyed this rule his C-point would have been at point X (fig. 258) quite near the picture. In that case the perspective of the vertical building lines would have been as violent as those in fig. 262A.

Now the location of that C-point is a purely arbitrary matter. Put it where it will give the most satisfactory effect to your picture.

261

Drawing by Frederick Siebel for an advertisement for John Hancock Mutual Life Insurance Co.

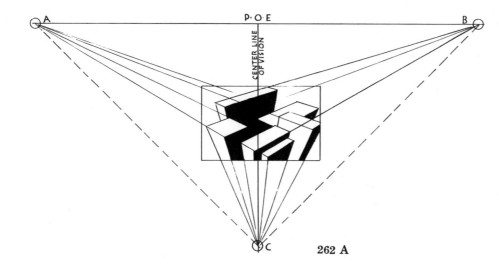

P.O.E

CENTER LINE OF VISION

262 A

HORIZON LINE POE

CENTRAL LINE OF VISION

THE increasing use of curare as an adjunct to various types of general anesthesia, as reported in recent papers, serves to emphasize a concept in anesthesiology which may result in great improvements of the art. This concept is the realization that insensibility to pain and muscular relaxation are separate and distinct effects—not inseparable components of the same effect. It has always been recognized that sufficiently "deep" anesthesia, produced by almost any agent, would result in muscular relaxation, but the idea that profound muscular relaxation must occur in every "satisfactory" anesthesia has, by force of necessity, been subjected to drastic revisions. Anesthetists have come to realize that a "satisfactory" anesthesia for the patient is not the same thing as a satisfactory anesthesia for the abdominal surgeon. For the patient, freedom from pain is all that he desires; for the abdominal surgeon, a much deeper depression of the sensorium is required when single anesthetic agents are used. Realization of this double requirement has led to methods whereby the needs of both the patient and the surgeon may be met with a minimum of jeopardy for both. To produce the essentially separate effects, separate agents are used: curare is given for muscular relaxation; general anesthetics in small doses are administered for the obliteration of pain.

Of the various anesthetic agents that have been used in conjunction with curare, Pentothal Sodium has proven nota-

Curare . . .

AND IMPROVEMENTS IN ANESTHESIA

266 *Courtesy Abbott Laboratories, North Chicago, Illinois.*

HORIZON LINE

CENTER LINE OF VISION

A

B

TO POINT C

267 268

It is appropriate here to point out again that what is proper in perspective drawing depends upon the use to which it is to be put. As has already been explained, the painter thinks nothing of violating the rules for the sake of better design in his pictures. The illustrator, who usually aims at literal representation, has to come close to photographic appearance; he usually avoids obvious distortions. On the other hand he finds distortions useful, even necessary, in certain types of demonstration drawings in which "normal vision" is inadequate. An example of this is the *Curare* picture on page 122. In this we see the same acute angle effect in the foreground as in the Siebel drawing. But we shall see that no "correct" perspective rendering of this subject would permit such a comprehensive illustration of the hospital's functioning as is here made possible by distorted perspective.

Note first that the observer is brought very close to the corner of the building, a factor that accounts for its acute angle. Of course the eye could never see it like that, but the camera could.

However, it might be asked why that left vanishing point would not as well have been pushed further to the left and the sharp corner avoided. In that event the over-all horizontal dimension of the building would have been considerably increased, necessitating, perhaps, a reduction in the scale of the picture as a whole in order to get it on the page. Furthermore, the left wall, in that case, would obscure much of the interior rooms on the near corner. As it is we have an almost unobstructed view of the operating room on the top floor.

Another good reason for the violent perspective is found in the very pleasing layout of the page, due to that sharply pointed building silhouette (see the layout analysis).

Looking down into the first three floors we see how by establishing another arbitrary vanishing point for the X-lines far to the left for the end walls of the rooms, it was possible to give these rooms better illustrative clarity than would have been possible had the X-lines been made to converge with the building lines to A. As a matter of fact, the artist did not bother actually to carry those X-lines to a single point; they merely take a general direction to a vanishing point.

Note that the C-point is far below the picture.

Thus far we have considered three-point perspective of objects seen far above. Now let us get back to the ground and do some looking up. This involves the exercise of even greater judgment and more subtle strategy. Even though our eyes have, through photography, become conditioned to great distortion in this kind of three-point perspective, the illustrator cannot always "get away with" effects that are acceptable as photographs; because, after all, almost every one does recognize the limitations of the camera through his own amateur experience and subconsciously makes allowances for effects that will not be accepted from an illustrator.

In photography it is often impossible for the camera man to view his subject in such a way as to avoid distortions. He may be obliged, when working in narrow or busy streets, to take positions which give unavoidably distorted results and, for the sake of detail, get too close to the subject for "normal" observation. The illustrator is not limited by these conditions. And even though he is required to draw the subject from a specified viewpoint which would give unpleasant distortion in photography, he has devices in his bag of tricks that enable him to come up with a rendering that does not offend the eye.

It will help the student to make a collection of pictures—both photographs and drawings—involving this upward-looking problem. Careful study will help him to acquire a sense of what is acceptable to the eye.

269

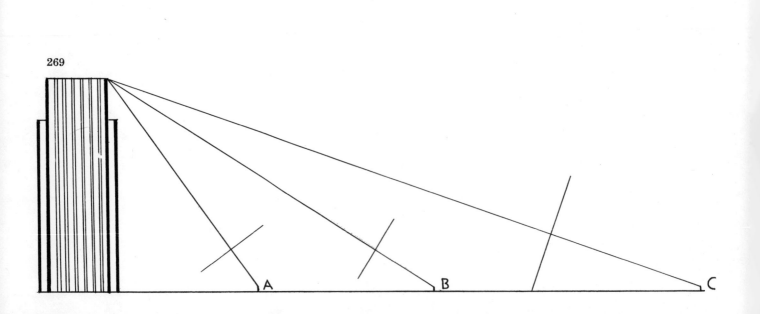

Everyone is familiar with the distorted effect of buildings when photographed with the camera tilted upward as in fig. 270, opposite. That is an unsatisfactory and unnatural impression, one that would never be seen by the human eye.

What about the picture of the skyscrapers, fig. 271? Do we not see here exactly what a person would see when looking up as the building lines converge skyward? The answer is yes. What is the condition that makes this effect acceptable and at the same time makes that of fig. 270 unacceptable? We find the answer in fig. 269, where the spectator is shown at three different observation points, A, B, and C. Stationed at A, very close to the building, he has to tilt his head back and look skyward in order to see the top of the building. When doing so, his picture plane tips at an angle and through it he sees exactly what is illustrated in fig. 271. While looking up he simply cannot see the base of the building. The camera has a much more extensive range of view, as illustrated in fig. 270.

At station point B (fig. 269), the spectator is in a more favorable spot for viewing the building as a whole, but even here the situation is similar to that of the A observer. Observer C is far enough away to have a comfortable view of the entire structure; and his central direction of sight indicates a picture plane that is less tilted from the perpendicular. This means that there will be some upward convergence of vertical lines, but not much. It is probable that normally the spectator's range of vision does not exceed a 30-degree angle. C's range is slightly less than 30 degrees.

270

271

272

STAHL

The drawing of Radio City (fig. 272) is a good illustration of a skyscraper's appearance from station C. Now in this drawing, when we focus on the lower part of the building, we are not disturbed by the *slightly* converging lines of the vertical. And in looking upward there is enough convergence of verticals to create the normal perspective effect of towering height.

What Ben Stahl did in his picture (page 127) is very interesting. He did here what we have just said could not be done satisfactorily. We should have qualified our statement by saying that *usually* it should not be done. A master illustrator like Stahl can and does do things that are difficult for the less creative and less experienced. The eye-level here is the foundation line of the church. Yet from the way in which the whole picture is handled, especially the figures in the foreground, we have the impression that the spectator's eye is perhaps on the level of the extreme bottom of the picture. The question is, "Is the effect better—more dramatic—than if Stahl had kept the upright lines vertical, which would be a more 'logical' thing to do?"

This brings us again to the axiom that the creative illustrator is never the slave to rules or even to logic. He is a dramatist and he uses his imagination and his skill to achieve his purpose, violating rules when this serves his purpose. It would be a profitable experiment for the student to copy this picture, "correcting" the drawing of the church by making its upright lines vertical.

273 *"The Lord Was Their Shepherd," painting by Ben Stahl' for John Hancock Mutual Life Insurance Co.*

W X Y Z

275 274 276

277

278

REFLECTIONS

To one who knows perspective, reflections present very little difficulty. Indeed, it is only necessary to point out a few simple truths such as can be demonstrated in a brief chapter upon the subject.

The whole matter may be summed up in a single statement: "The reflection of every *point* is located directly underneath, as far below the reflecting surface as the point is above." Thus the reflection problem may be considered as involving but three points, A, the point to be reflected; B, the point on the reflecting surface directly underneath; and, C, the reflection of the point. So we shall refer to A-point, B-point, and C-point in describing the operations which are controlled by these points.

The reflection of a post set vertically in the water, as in (W) fig. 274, is its exact image inverted. Likewise the post set at an angle in a plane parallel to the picture plane (X) reproduces itself in the reflection, the reflection being the same length as the post itself. In (Y) and (Z) the conditions give different results. The posts inclining forward (at Y) and backward (at Z) make reflections differing in length from the posts. Such variations in length of objects and their reflections will not confuse the student who remembers the relationship of points A, B, and C. Point C is always as far below B as A is above. That is the key to all puzzling situations. So long as one is content to find the reflection of one point at a time, little perplexity will be experienced.

A building seen on the water's edge (fig. 275) reflects a perfect image of itself in the water *provided the spectator's eye is near the water line.* Fig. 275 appears as a bisymmetric shape bisected by the water line. Occasionally, the camera catches such effects so perfectly that it is difficult to distinguish reflection from reality and the picture seems as true upside-down as in its correct position. But when the eye-level is considerably above water-level the object and its reflection differ radically in effect, as illustrated in fig. 276.

This is more easily understood if one thinks of the reflection as a part of a bisymmetric solid with its lower half submerged. The reflection appears exactly as the lower half of such a solid figure would appear when looking down upon it, and its drawing is dictated by the same rules of perspective which are associated with the appearance of objects.

In the rule stated at the beginning of the chapter, we learn that "the reflection of every point is located directly underneath, as far below *the reflecting surface* as the point is above." When the object is *above* the water line and *set back* from its edge (fig. 277), the student will have no trouble in finding his C-points if he remembers that the B-points must be on the water-level. The dotted lines underneath the building indicate the plan projected down to water-level to locate B-points.

Fig. 278 represents a familiar and interesting situation. Conceiving the reflection as a submerged duplicate of the bridge, reflections and bridge become a solid mass of masonry with cylindrical tubes or tunnels passing through it. When the tunnels have been constructed according to the usual perspective method, the reflections have been properly indicated.

284

Advertising drawing by I. W. Ferguson,
Advertising Manager for H. H. Robertson Company.

279

280

281

282

283

Now, referring to the powerhouse (fig. 284), we note an interesting violation of natural appearance. Had the rules been followed, the smokestacks and the PWR sign would not have appeared in the water; instead there would have been an uninteresting reflection of the vertical lines of the rectangular masses. Note that the illustrator chose not to show reflections of the steel tower and the conveyor chute. A good exercise for the student is to "correct" this drawing, making the picture deep enough to accommodate the entire reflection. Eliminate the boats in order to allow for the reflection of the steel towers.

Let us consider, next, reflections by vertical surfaces such as are seen in a mirror on a bureau or dressing table. In fig. 279 we have a box that represents a jewel casket. It touches the mirror. (For the sake of simplicity we will suppose that the mirror has no frame.)

Our procedure is the same as in water reflections, as is readily seen when we tip the drawing up (fig. 280) so that the mirror is horizontal. The mirror reflects the casket exactly as though it were water reflecting a building at its edge. This simile will be especially helpful in visualizing what happens when the mirror is tipped forward, as in fig. 281.

The bottom line of the mirror swings up as well as backward; so our first step is to project the glass downward until it meets the plane of the dresser top, extended backward at the dotted line X. Then we can project the lines of the casket back until they touch the glass.

Now in fig. 282 we tip the drawing up again so that the mirror is horizontal. Following the procedure already demonstrated, we find B-points on the mirror vertically under A-points, on lines marked Y which are parallel with the short lines of the mirror. The C-points are thus easily located.

In fig. 282 where we liken the mirror to a sheet of water, the AC projection lines are vertical. They "pass through" the mirror at *right angles* to it. That is what we always must remember about reflections: the projection line always "aims" at the reflecting surface at right angles to it. It is not as easy to judge its direction when the reflecting surface is tipped at an angle as in our present problem, but that is what we have to do. It is not always practical to turn the drawing to get the mirror in a horizontal plane as we did here. In fig. 283 we see the problem's solution.

Innumerable other conditions might be illustrated here but they would not introduce new principles. If the foregoing is thoroughly assimilated and if the student has become structurally-minded enough to work with projected lines and planes, there should be no difficulty in solving any problem that is likely to be encountered.

285

286

287

288

289

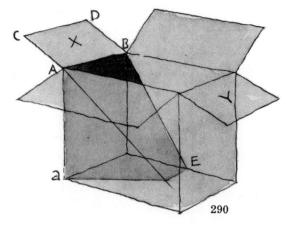

290

SHADOWS

In our study of reflections we concentrated upon finding reflections of *points*. The procedure with shadows is somewhat similar; we look for shadows of points that, when properly projected, provide direction for lines that bound the shadows.

The method is illustrated in fig. 285, which represents the line AB casting its shadow BC. In all of these examples the sun's rays are coming from the left in a direction parallel with the picture plane, at an angle of 45 degrees, a direction arbitrarily assumed in all our demonstrations wherein the sun's rays come directly from the left side. The shadows of all verticals, on the ground, therefore are horizontal. When the sun comes obliquely toward us, the method of locating points and finding shadows is no different. It will be found, however, that the shadows of verticals, instead of being horizontal and parallel, will converge to a vanishing point on the horizon directly underneath the sun. This is illustrated on page 136.

The shadow of point A is point C. So let us think of every point that casts a shadow as the top point of a pole set in the ground. When the point we are working with is not connected with the ground, we have to drop a line from it to the ground. In fig. 286, for example, we drop a line from point A to point *a*, directly under it. We locate this point by projecting forward the base line of the box end, *bx*, which we know will be directly under line AB, whatever the position the hinged box flap happens to take, since the line AB swings in the same plane as that of the box end (fig. 287). To find the direction of the shadow of line AB on the ground we have to locate the shadow of point B; that is, where it would be if the vertical line B*b* stood alone instead of being the edge of the box. Thus we find the line C*c*. From the point D, where C*c* cuts across the bottom of the box, the shadow of AB is BD.

It will be seen in fig. 288 that all the other box flap points are similarly found by projection of the planes in which they lie. Just take each point, one at a time, and there should be no confusion. Finding the shadow within the box (fig. 290) presents no new problems. It is only necessary to find the shadow of point A, just as though line A*a* stood alone instead of being the box corner. We know that the shadow of line AB is parallel with it, hence converges with it: so we do not need to find the shadow of point B.

The only other question that might arise is whether or not the box flap X is in shadow. We find the answer in fig. 289, where, it is discovered, the shadow of the line CD falls within the shadow line of AB, which means that plane X is in full light and therefore it casts no shadow that is visible in our drawing. If the X flap were in shadow, the line CD would, of course, cast its shadow on the ground, and line AB, then being in shadow, would cast no shadow.

Let us now study shadows cast by a flight of steps, fig. 291. First we find the shadow CD of the line AB, which may be considered a wire stretched taut between these points and touching the corners of intervening steps. Actually, point B casts no shadow at all. But it would if the wall went back—a continuation of the side plane of the steps—along the dotted line BX. The shadow of point B would then be point D. From the steps' corners we project diagonal light rays to intersect CD. These points are all we need, since we know that shadows of the treads are

292

291

parallel with the treads themselves and thus converge with them. The shadows of the vertical risers of course are horizontal.

We see that the shadow of point N falls close (point Q) to the base line of the wall. Hence the shadow of the top tread NE is very short on the ground. From the point where it cuts across the base line of the wall it goes up the wall to point E.

Going to the other end of the steps—to find the shadow cast upon them by the balustrade—we start with the shadow of GH. It crosses the first step horizontally and vertically up the second riser, proceeding horizontally again on the second tread until cut by the light ray from G at point K.

From this point on, the shadow lines on the treads will not be horizontal; we have to find the direction of lines cast by the balustrade's inclined line GL. We locate the shadow O of point M on the plane of the second tread extended back under step 3. A line connecting this point O and point K, shadows of points M and G, respectively, establishes the direction of all shadow lines cast by the inclined line GL on the horizontal treads. They will all be parallel and will converge to a vanishing point at the right.

To ascertain the direction of the shadow from point P on the riser of step 3, it will help to imagine the third riser extended upward as high as R on the balustrade (fig. 292).

Now if we draw lines ST and PU parallel with AB and HW—consequently converging upward with them—we have points for our shadows on the upper treads.

We need, at this time, to find Z the shadow of point L on the platform. That is where the shadow of the sloping balustrade ends. From point Z the shadow parallels the line of the horizontal balustrade.

In fig. 294 we simplify the procedure of finding the shadow of the desk-top's overhang by imagining that the drawer compartment X extends to the floor. Here we see the shadow of the imagined line AB rising vertically on the box side until cut off at C by the sun's ray from A; the shadow of a vertical upon a vertical plane being always vertical.

The diagram in fig. 296 carries us one step further, giving the shadows of points A and R on the floor. The *actual* shadow of point A, as was seen in fig. 294, is point C. However we need point O as well as point P to give us the width of the desk-top's shadow.

In fig. 297 we develop the shadow of the X unit. It will now help us to imagine the right unit (fig. 295) as a simple box-like object resting on the floor instead of being raised on legs. Then when the converging shadow lines from P and O meet the base line of the plane Y at H and K, they streak upward across the Y plane to M and N, though of course they also continue on into the shadow of the right unit and merge with it on line S.

293

294

295

296

297

298

299

In fig. 298 we are facing the sun, whose position has been arbitrarily placed at the right of VP¹. Its rays, which approach the earth in parallel lines, are subject to the same laws of convergence as any other parallel lines. Probably every one has observed the phenomenon which is a common sight in great railway terminals when the rays of sunlight, broken up into streamers by the mullions of the big windows, are made visible by the hazy atmosphere of the interior. When viewed from the side, the rays are parallel. When one faces the window, they converge perceptibly.

So in fig. 298 we see the sun's rays striking the corners of the posts and cutting off the shadows, which converge, not to VP¹, but to a point (VP²) on the eye-level, directly under the sun. Note however that the shadows of the retreating top side lines of the two left posts (marked with arrows) cast shadows that converge with them to VP¹.

Note that in order to find the shadow of the "Road Closed" sign, we first have to find our ground points as previously demonstrated.

In fig. 299 similar posts are illuminated by an artificial light whose rays come from nearly the same direction as those from the sun in fig. 298. There is an important difference: to find the shadows we drop a vertical from the light source to a point on the ground—it is in a horizontal line that passes through the pole's base—instead of to the eye-level as we do when the source is the sun. All shadows, we note, converge to this point (VP²) on the ground under the light.

Let us next consider shadow problems in an artificially lighted interior. Instead of using a logical interior for this demonstration, simple objects which provide greater clarity than conventional furniture have been chosen (fig. 300). In this diagram, in order to avoid confusion of many lines, we have omitted vanishing points and converging lines of the objects in the room.

The light (X) here is in the ceiling a little to the left of the center.

Our first step is to find on the floor the point directly under it. Carrying a horizontal line to point W, thence down the wall to the floor line (V), we next run a horizontal line along the floor until it cuts a vertical from X at point Y. We now have a vertical plane XWVY parallel with the rear wall and of course Y is directly under X.

The procedure for finding shadows by artificial light has already been explained. What we always have to keep in mind to avoid confusion is to find one point at a time.

To find the shadow of the top of the cabinet on the middle shelf, we project a horizontal from point Z on the shelf's level, in the plane XWVY. We erect a vertical through A, the point where the line from Z crosses the shelf line. This gives us point B on the top shelf and we find its shadow C. A line through C, the length of the shelf, to VP is the shadow line we are after. The shadow of the shelf on the bottom of the cabinet is found by a light ray through A to D on the VY line.

It will be noted that the box is not set parallel with the floor lines. Its edges have vanishing points not shown in the drawing. We need only to project one light ray—through point O— to find the shadow of the box on the floor because the shadows of both edges of the box will be parallel to those edges themselves, hence converging with them.

To find the shadow of the stick on the box, we have to find the point on the floor directly under one of its ends; it doesn't matter which. We do this by dropping a vertical to the floor from the point where the stick crosses the box corner, then draw a line along the floor *parallel with the stick*. Where it meets a vertical dropped from the end of the stick, we have the point we need.

All shadows of vertical lines are vertical when they fall on vertical surfaces, as does the shadow of the front vertical edge of the cabinet when it strikes the wall.

The student is advised to experiment with the light in different positions in the room. Place the light on each of the three walls.

Ordinarily, cast shadows are darker than the shaded sides of objects which cast them. The reason for this is that light is reflected upon the objects from lighted areas of floor or wall. This is not always the case. All depends upon the conditions in the room, the colors of objects and reflecting surfaces, and the position of the light. Although this relationship is generally observed in our demonstration drawing, the shadow effects are only approximate, realism being sacrificed here to clarity of procedure.

300

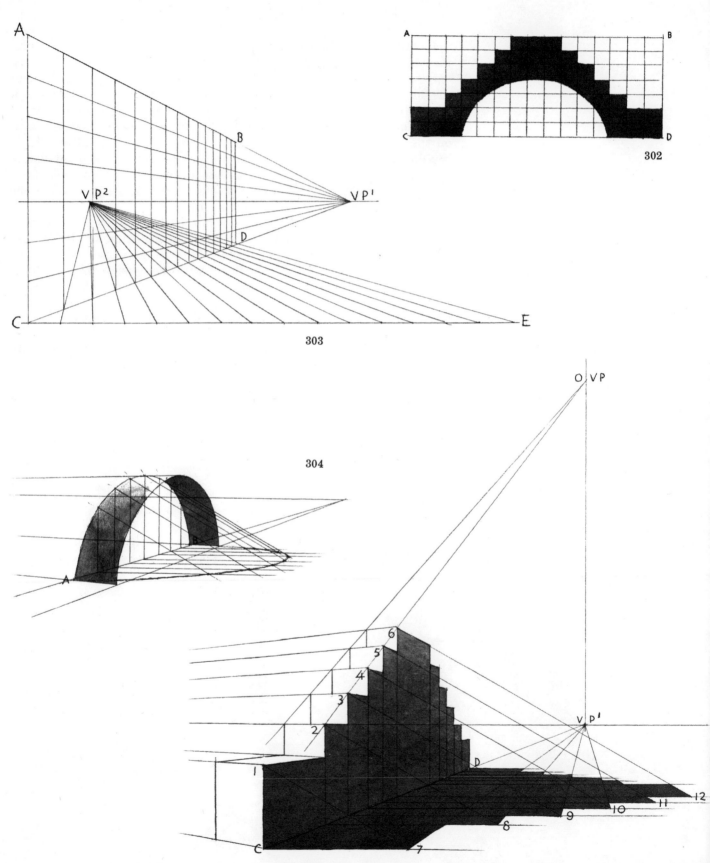

A
B
C
D

302

A
B
V P²
V P¹
C
D
E

303

304

O VP

6
5
4
3
2
1
V P¹
D
C
7
8
9
10
11
12

305

301

Now for the arched entrance (fig. 301). Although a complete description of its construction repeats some instruction given elsewhere, the problem is sufficiently interesting to justify a step-by-step demonstration.

The side elevation (fig. 302) gives the needed structural facts. In fig. 303 we have constructed the grid in perspective. On line CE we have measured the 15 equal horizontal dimensions. These could have been a little more or a little less; all that matters is that they be equal. From E a line is projected through D to the horizon, giving us a vanishing point for all lines from the points on CE. These lines, cutting across CD, mark off perspectively equal spaces on that line.

Having stepped-off the seven vertical measurements on AC, we now have all needed points for constructing the grid.

In fig. 305 we concentrate upon the shadow of the structure without reference to the arched opening, the shadow contour of which is developed in fig. 304. In fig. 305 we see horizontal lines carried out from each point on line CD underneath points 1, 2, 3, 4, 5, and 6 and corresponding points on the far side of the structure. From points 1, 2, 3, 4, 5, and 6 sun rays are projected to the ground at a 30° angle. Where these rays cut corresponding horizontals on the ground we have the shadow points 7, 8, 9, 10, 11, and 12.

It is not necessary to project the sun rays from points on the far side of the arch corresponding with 1, 2, 3, 4, 5, and 6; their shadow points are found by the crossings of the parallels from 7, 8, 9, 10, 11, and 12 which converge to VP[1].

The inside of the arch that faces us received some of the sun's rays. However, there would be a shadow cast upon it by itself—see fig. 301; that entire area is arbitrarily shaded in fig. 304. This shadow can be developed by rather complicated mechanical procedures, but no illustrator need go to that extreme. Simply hold a strip of stiff paper (curved to simulate the arch) up to a bright light so that its light rays approximate the direction of the sun in the drawing. As a matter of fact, a great many of the problems carried out mechanically in this book can be more naturally solved by simple observation with the use of makeshift models.

In finding the curved shadow edge in fig. 304, we first set off an indefinite number of points on the arch and drop verticals to line AB underneath. From the points on AB, horizontals are projected. These are cut off by light rays passing through the points on the arch, giving the desired curved shadow line.

Any number of points can be used on the arch for this procedure. They can be located at random; it is not necessary to have them mechanically spaced.

306

307

308

309

310

chapter xvi

FURNITURE

There is nothing difficult in the drawing of furniture for the student who has acquired the habit of analysis and structural thinking. The drawings in this chapter are self-explanatory.

Wherever we have several pieces of furniture placed in relation to each other, we begin our drawing with the floor plan, as illustrated on the opposite page, where chairs are drawn up against a table. In drawing an entire room all the furniture would, of course, be laid out in plan in this way.

Throughout the book we have emphasized the importance of acquiring the ability to draw the various geometric figures in perspective with great facility and to know how to draw one figure in proper relation to the others. Thus in the office chair, below, it is important that the ellipse, which we use to locate the four legs, be correctly proportioned to the square seat. Turning to page 143, we see the triangle, the square, and the circle in essential relationships.

Most furniture is based upon relatively simple geometric forms. In our drawing we first reduce the object to these forms, ignoring until later the character variations. If the basic structure is right, the details readily fall into place.

In addition to drawing directly from furniture in the home, the student is advised to do a great deal of drawing from photographs in furniture advertisements. Make analytical studies of them as we have done on these pages. Try turning the tables on page 143 so that the triangle and square will have a different relationship to the circles in which they are inscribed.

Tracing paper is very useful in studying photographs of furniture. Lay it over the piece being studied and make the analysis with the pencil.

311

312

313

Courtesy Heywood-Wakefield Company.
314

315

316
Courtesy Knoll Associates.

317 318

319

320

321

324

323

322

325

326

327

Courtesy Mason-Art Furniture Company.

328

329

330

331

332

"Still Life with Fruit Basket"
by Cézanne
(French, 1839-1906).

333

Perspective analysis
of Cézanne's still life by
Earle Loran from his book
Cézanne's Composition,
published by the
University of California Press.

UNIVERSAL PERSPECTIVE

The notion that objects and nature ought always to be drawn and painted as they appear to the photographic eye is of relatively recent origin. For thousands of years artists had been chiefly concerned with expressing their *ideas* without regard to imitative accuracy. They did not hesitate to depict a man bigger than his horse or even his house. After all, wasn't a man more important than either? In a company of people, those furthest away were apt to be as large as those in the foreground. That permitted the artist to portray all with impartiality.

If the artist wished to illustrate more of an object or an episode than could be seen in a single view, there was no reason why he should not combine several views in the same picture. And he often did.

When we compare present-day illustration with that of pre-perspective days, trying to free our minds from the prejudice of traditional ways of thinking, we are forced to admit that the old boys had rather the better of it. When it comes to the expression of *ideas,* an artist who is not bound to make things look "natural" can say a whole lot more in a picture than contemporary illustrators who are limited by the restrictions of the camera eye.

It was easier for the early artist to paint better pictures because, unchained by the necessity of composing his subject so that it would meet the test of photographic accuracy, he had a freer hand with his design. He could arrange the elements of his subject as they would look best *as design.*

So-called modern art has adopted many of the ideals and the methods of the ancient masters. Modern artists—we refer now to painters—have revolted against the concept of photographic reality. They ask why the painter should attempt to compete with the camera which produces —theoretically—accurate imitations of nature. Since the perfection of color photography their argument seems even sounder.

So they distort perspective or ignore it altogether. They arrange their subjects with utter disregard of natural effect, if they so desire. Their emphasis is upon design and the expression of a mood or an emotion.

CÉZANNE One of the first "moderns" to revolt against the academic ideal of naturalism was Cézanne (1839-1906). He adopted the practice of what has been called *universal perspective,* that is, the combination of several views in a single picture. His method is so clearly demonstrated in Erle Loran's exciting book, *Cézanne's Composition,** that I have asked Mr. Loran's permission to reprint his analysis of Cézanne's *Still Life with Fruit Basket.* He has kindly consented. The diagram and the following explanatory text are taken directly from the book.

"The diagram reveals sources for many of the devices of Abstract painting, principally the incorporation of several eye-levels in one picture. The first eye-level, marked I, takes in, roughly, the front plane of the fruit basket, the sugar bowl, and the small pitcher (the last two objects are seen at slightly higher eye-levels). The second eye-level, much higher, marked II, looks down at the opening of the ginger jar and the top of the basket, as well as other objects, including the table top.

*University of California Press.

"The result of these distortions is a greater sense of three-dimensionality, but at the same time, paradoxically, these top planes of the ginger jar and basket, being tipped forward, also relate clearly to the flat plane of the picture. The endless tensions between planes seen at different levels but related also to the picture plane are the basis of the mystery and power of this still life. An emotional, nonrealistic illusion of space created by the changing of eye levels has been the point of departure for Abstract art as well as for a revived interest by Byzantine icon painting. This device, mentioned elsewhere, is sometimes called 'universal perspective'. . . .

"Another distortion shifts the artist's viewpoint from the left side to the right side of his motif, increasing the illusion of space, of 'seeing around' the object. The change may be traced from the vertical arrow at I*a,* which indicates the straight front or slightly left-hand view from which the table and most of the objects in the picture are seen. But the handle of the basket is turned, as if seen from a position far to the right, II*b.* Picasso's familiar device of incorporating front and side views in a single portrait head is perhaps traced here to one of its sources.

"An extraordinary distortion may be observed in the splitting of the table top. The dotted line from A to B indicates the tension that develops because the table plane fails to unite under the cloth. The arrow at C emphasizes the tension, the pushing back into space, that results from this splitting of the table plane. Abstract artists have resorted to the breaking up of planes and objects in a highly intellectual and conscious spirit, sometimes dividing the picture plane into a dark and a light area, sometimes even sharply dividing an object, as in the familiar table pictures of Braque. Many examples of split table planes exist in Cézanne's still lifes. . . . It should be pointed out, however, that the two sides of the table in this still life tend to converge in a more or less normal kind of perspective. In fact, so far as I have observed, there are no table tops in Cézanne's still lifes that actually expand in direct reversal of mechanical perspective; his lines tend, instead, to be parallel. . . .

"The last distortion explained in the diagram recalls Cézanne's habit of tipping the vertical axes of nature to the right or left. The sugar bowl and pitcher, marked D and E, are falling definitely to the left, while the ginger jar, F, remains vertical. The play and tension between axes continues throughout the entire painting, with the strongest axial variations occurring in the pears.

"The conflict and dualism of static and dynamic axes, the plane tensions resulting from the shifting of eye-levels, the action of three-dimensional space forced to maintain its relation to the picture plane—these are the elements of the inner life of Cézanne's art."

GAYDOS We frequently encounter instances of universal perspective in contemporary illustration. In the advertisement by Gaydos, fig. 334, for example, there are three distinct eye-levels; one for the goblet, gloves and candy, another for the teacup, and the third indicated by the horizon line.

*Advertising design by Gaydos
for Niagara Alkali Company.*

334

Alexander F. Yaworski in his watercolor of Galena Station (fig. 335) has employed two eye-levels for a very interesting reason. Fig. 336 is a view as it would appear when seen from above. This sketch was made to show that neither the boards of the platform nor its edge are parallel with any of the building lines.

YAWORSKI

In fig. 337 we see the boards of the platform converging to a point far above the eye-level used for the building. The importance of this may not appear in the small reproduction of his large painting, but if the vanishing points for the boards had been put on the eye-level, the design effect would have been unsatisfactory. We have taken the liberty of inking some of the board edges in the photograph because they do not show up in the reproduction as in the original.

A watercolor by Alexander F. Yaworski. The black board lines were added by the author for purposes of demonstration. 335

336

337

EYE LEVEL

HORIZON

chapter xviii

FIGURES IN PERSPECTIVE

This subject is dealt with in Chapter XI and on page 59. In those demonstrations we see lines converging to the horizon line from the feet and heads of foreground figures. Naturally, all verticals extending between those horizontals are of equal height. That, to be sure, is a simple procedure, but another that is often used by layout men and illustrators is demonstrated here.

Note that in fig. 338 the horizon line passes through the centers of the two foreground figures; there is as much of the figures above as below the line.

Now what is true of the foreground figures is also true of any others on the same horizontal plane. So all we have to do, having established the foot position of any figure anywhere, is to place the head as far above the horizon as the feet are below.

338

*Drawing of the foreground horseman
by Constantin Guys (French, 1805-1892).*

339

GUYS In fig. 339, see above, the eye-level is lowered to the level of the horse's knees—about one-quarter the height of horse and man. Thus all other horsemen would be one-quarter below the line and three quarters above.

Suppose we wish to draw a man in the middle distance. We cannot use the one-to-three ratio. Assume that the man's head comes about up to the horse's mouth. That gives a one-to-two ratio—the man's head will be twice as far above the horizon as his feet are below.

In fig. 340 the eye-level is considerably above the foreground figures, whose height is approximately two-thirds the distance from their feet to the eye-level. The height of other figures on the floor therefore is two-thirds the distance from their feet to the horizon, regardless of their position on the floor.

340 *Drawing of the foreground group by Constantin Guys.*

When we have a situation similar to that in fig. 341, the procedure is different, though the principle is the same. Usually, though, the illustrator, in a composition like this, would begin with the foreground figure and scale others to it, just as when there are full figures in the foreground. Then he would establish an eye-level.

In this case we have conveniently located the eye-level one head's height above the head. The ratio, naturally would apply to all heads in any part of the room. This is a very simple method, one that can be applied in most situations, though not in all. The eye-level can be lowered or raised as desired. We merely have to apply the ratio of the foreground head to eye-level distance above it.

341

LEVEL OF OBSERVER'S EYE

342

Advertising drawing by Fred Freeman for
Combustion Engineering-Superheater, Inc.

343

FREEMAN Here is a superb drawing by a distinguished American illustrator, Fred Freeman.

The excellence of this drawing derives from many factors not directly related to perspective: thorough knowledge of horses, authenticity of the fire engine, and fine rendering in the black-and-white medium. Over and above these is the masterly manner in which the scene is dramatized; in this, perspective strategy plays an all-important part.

It certainly would not occur to anyone lacking a prying, analytical attitude that Freeman had solved an unusual perspective problem here. Perhaps you the reader are not aware of such a problem. As a matter of fact there are two striking violations of scientific perspective.

First, observe that the horses are traveling in a different direction than the fire engine: they are heading more directly toward the spectator than is the vehicle. The diagram in fig. 344 illustrates this. In order to "correct" this discrepancy, the vehicle would have to be drawn somewhat as it is in our "reconstructed" rough drawing (fig. 343). Either that, or the horses would have to be shown more in sideview—in which case much of the drama would be lost.

In fig. 345 we have indicated another liberty that Freeman took with reality—an amazing liberty it is and a daring one! The three horses are not really running parallel; although they appear to be parallel to each other, they take positions roughly like those indicated in fig. 345.

Now what is accomplished by this? Obviously that relative position of the horses gives us a head-on view of all of them—a most important factor in the smashing success of the drawing.

This drawing, almost more than any other in the book, demonstrates the importance of *knowing how* to *violate* perspective.

344 345

156

*Pencil drawing by the author
for an Eldorado Pencil advertisement.*

349

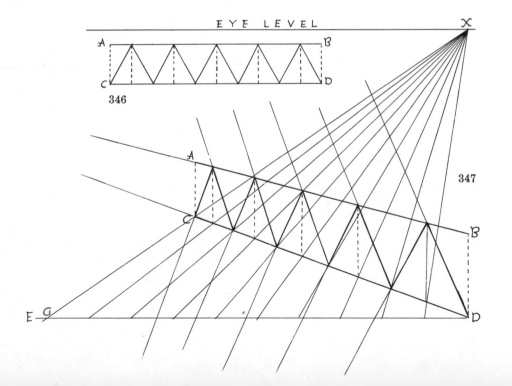

EYE LEVEL

346

347

PROBLEM OF THE BRIDGE TRUSS

The jacket picture of a bridge structure was made by the author after a pencil drawing used as an advertisement for Eldorado Pencils. The model from which the drawing was made was a paper construction, one of a series demonstrating various uses of the pencil.

While no principle or method not covered elsewhere in the book is involved, the procedure as here applied is interesting enough for demonstration.

In a problem of this kind it is useful to make a diagrammatic analysis that records essential facts needed for the perspective rendering. Thus in fig. 346 we draw a side view of the bridge truss.

Note that the base line CD is divided into ten equal divisions which locate the points where the triangular members touch both CD and AB.

Having decided upon the placing of the eye-level (fig. 347), we establish the desired direction of line CD and draw AB converging with it as shown in fig. 348. We find the ten divisions on line CD by the method already demonstrated on page 96. From point D we draw an indefinite horizontal line (DE) which will be our measuring line. From point X, arbitrarily established on the eye-level—it could have been farther to the left or to the right—we draw a line through C to G on the DE line. We now divide line DG into ten equal parts and from the division points carry lines to X, dividing line CD into the same divisions perspectively.

When the structural lines of the truss are drawn on the framework thus developed and the converging lines are carried out to their vanishing point, we have the diagram reproduced in fig. 349 on a small scale.

348

INDEX